Ex Libris
Thos. J. Fay.

Art and Faith

Art and Faith

LETTERS BETWEEN
JACQUES MARITAIN *and*
JEAN COCTEAU

PHILOSOPHICAL LIBRARY
New York

*TRANSLATED FROM THE FRENCH
BY JOHN COLEMAN*

Contents

Preface to the English Translation

This exchange of letters took place at a time in
the history of French poetry of which the young
men of today can have no idea, and whose painful
beauty, laden with fragile hope, remains in the
hearts of those who knew it as a resplendent break-
ing forth of the sun [1] through stormclouds during
one of those fall mornings in which the earth shines
with freshness and impalpable lightness.

A short period of freedom was still left for
poetry. While the world's structures were being
shaken and the foreboding of woe weighed on
it, poetry was entering deeper than ever into
its own mystery, dazzled by the revelations that
taking consciousness of itself brought to it, and
astonished at seeing that insofar as it came to know
itself it became involved in the supreme battle of
the spirit—there where the good and bad angels
fight each other, where poetic knowledge confronts
metaphysics and theology, and where the pursuit
of magical powers pulls in the direction of the

[1] Cf. Raïssa Maritain, *Jours de Soleil en France*, Les
Oeuvres Nouvelles, III, New York, La Maison Française,
1943.

Devil, whereas the savor of a foretaste of the contemplative intuition pulls in the direction of God. The poets had to choose. On the one hand Claudel, on the other the Surrealist poets invoked the name of Rimbaud. Apollinaire had announced an age more pure in which brothers who did not know one another would recognize one another. After our dear Max Jacob, whose death as a consenting and self-denuded victim in the concentration camp of Drancy was to reveal his greatness to those who had been unable to divine it; after Henri Ghéon; after Pierre Reverdy, Jean Cocteau had known the miracle of Faith. He entered a freedom which is the only true one, but which is more demanding and more difficult than he perhaps suspected. He was to give us *Orphée*.

Less than ever was he renouncing to be at the forward tip of the art of his times, and to playing his bird-catcher's flute. It was to inform his friends of the change in his life that he wrote me the letter whose English translation is appearing today.

He discussed in it his problems of a poet, and even of the effort he had to make to wean himself from that artificial paradise whose mirage leads astray the traveler removed from the paths of God.

I answered him by discussing my problems of a philosopher. We were careful not to mix up our ways, but we were tending toward the same goal and were trying to awaken to the poetry "for God" a period in which the Prince of the World was the master of Dreams. If our dialogue has been interrupted since then, the vicissitudes of life have not cut into the friendship that gave birth to it.

In different historical circumstances the deliverance we were hoping for might have occurred; the new poetry we presaged might have found its poets. To tell the truth, I do not wonder that this was not the case, and that after a moment of surprise the habits of literature went on as before. Even and especially in the harsh world of today, I have not given up the hope I was then expressing on the basis of frail signs. I know the poets in whom I have my confidence.

Moreover, the temporary failures have only a secondary importance. It is the testimony that matters, in the perishable day in which it has been borne. However it may be with the future of poetry, those who love poetry, and who are not indifferent to the mysterious and ambiguous relations it entertains with religion, may perhaps find in the letters

exchanged between a poet and a philosopher something to give them a few moments' thought.

J. M.

Rome, January 1947

In this new edition I have modified my own text only in two places, concerning questions subordinate to the central theme. Two notes have been suppressed, two others corrected.

Letter to Jacques Maritain

Prologue

Rome, in 1917, around Easter.

After fifteen days of work on PARADE which has not left us free to see anything, we are taking a walk, Picasso and I.

PICASSO: "Let us visit this church." (*The church is filled with the faithful, with chandeliers, tunes, prayer. Impossible to visit it.*)

MYSELF: "Let us visit another one." (*Same scene. Long walk in silence.*)

PICASSO: "We are living like dogs."

This letter closes a loop that begins with
LE COQ ET L'ARLEQUIN.

My dear Jacques,

You are a deep sea fish. Luminous and blind.
Your element is prayer. Once outside of prayer
you run into everything. Awkwardness, that is our
ground of understanding. The Thomistic appa-
ratus deceives the world on your awkwardness; a
mass of misapprehensions makes mine pass for
cleverness. We are not shrewd. The Shrewd One
would find traitors in us.

I myself am a bad student. At school I used to
win the dunce's prizes: drawing prize, gymnastics
prize. Now you are a philosopher. I should be
ashamed. But we are countrymen; that is to say,
we are two fish out of water of the same kind.

Imagine this, that I must constantly keep myself
in the air and practise flying. That is how I man-
age to take people in, and imitate liveliness of
mind. For unless I fall on things directly I am
unable to reach them by the normal windings. But
you do not cheat; you do not avoid any of the
turns. You rise when you please, from where you
please. You do not rise by means of a machine. You

rise like cork toward the regions which call you. I myself fly with a machine, and I progress by a series of falls. One of the reasons for my reserve in the face of insults is not arrogance, but the fear of not playing my part well in a controversy (1).[1]

Before I knew you, you used to quote me in your books. You had met George Auric at Bloy's; he must have been fifteen. When, some years later, I understood his budding genius and dedicated *Le Coq et l'Arlequin* to him, he read you *Le Cap de Bonne Espérance,* and secretly told you of my enterprise. For Auric pushes discretion to its extreme limits through a kind of defensive reflex. You were "his friends of Versailles," but I did not know which. When you liked my work, your group was so surprised that it believed the work was liked out of kindness. "Your friend Cocteau," one of your intimates used to say to you, one of those I knew long before I knew you. He could not understand then that, quoting me, you did not know me.

The distorting thickness of conceited prejudices prevents a man from seeing clearly. Nothing comes between the eye of a child and what he looks at. But a child, like a Negro, needs correctives. What

[1] Numbers in parentheses refer to the notes at the end.

is so wonderful about your glance is that it is pure and skillful.

A mind like mine gets tangled up in calculations, and gets lost ten times in an hour when it tries to read a map. I could take only one method, and I took it: sincerity. Tell all, spread all out, live naked. I was counting on our paltry limitations to make up for those that a strong man decides on himself. I feel also that mystery begins only after the avowals have been made. The hypocrisy, the secretiveness people are used to taking for mystery —these do not cast a fine shadow.

Now the sincere man is not believed, and since he never contradicts himself, since he manoeuvers without any difficulty, he passes for a skillful player. This method presents the advantage of doing away with all strategy, and—with everyone seeking truth far away from truth—a legend is formed around the poet who is systematically sincere that pretense could not bring about.

My own legend was mad at the time we met.[1]

[1] Because the restaurant in vogue carries the title of one of my mimes [form of drama] it is believed I run bars; a night owl career is ascribed to me; all sorts of customs, vices, extravagances are laid to my account. You know my habits.

It protected me. Public opinion tears apart the character it invents. Instead of burning us it burns us in effigy.

For the worldly spectator the gesticulation of a tightrope-walker must seem funny. You who divine, you who feel pity, you saw [1] at once that the step was a sickening struggle, eye to eye, with death.

After the scandal of *Parade* at the Châtelet in 1917 two remarks flattered me greatly. First a theater manager crying: "We're passed the Guignol [2] age"; then a man that Picasso and I heard saying to his wife: "If I'd known it was so silly I would have brought the children."

I maintain it was the child in you who saw me. The child saw the child. Thus children devour each other with their eyes from one end to the other of a table of grownups.

Yes, my dear Jacques, long afterwards, dining for the first time in your dining room at Meudon, I found again the odor of Maisons-Laffitte where I was born—the same chairs, *the same plates* that I

[1] Cocteau is referring to the tragedy of the poet, who stakes his own life and confronts death whereas people think that he is only playing as an acrobat. *Tr.*

[2] French puppet show. *Tr.*

morbidly used to turn about so the blue designs would coincide with the foot of the glass.

It was under the sign of childhood that we got to know each other. I must repeat this to myself to feel worthy of your welcome, you about whom one wonders whether your body is not a formula of politeness, a garment thrown quickly over the soul to receive your friends.

The Peasants of Heaven

Paris wears me out and buckles my wheel [1]; for thirteen years I have gone into society; I am a man of solitude and wild pleasures.[2]

[1] "Paris m'éreinte et voile ma roue." Paris wears me out [or: breaks my ribs] and buckles my wheel [the wheel of my bicycle]. *Tr.*

[2] The war—this is understood—the North, the Somme. One can understand in *Le Discours du Sommeil,* and between the lines of *Thomas,* the crime of frivolity I nearly committed by *loving war,* because of this providential break with social duties. To say, "I was in the War," is highly ridiculous. I did not even answer certain mocking inaccuracies in *l'Echo de Paris.* My brother sets the example of tact. Covered with medals, with triumph, he hardly wears his Legion of Honor ribbon.

At Piquey I lived in a shack; after eight days of walking barefoot you get a horny sole. You can walk on seashells, on broken bottles without hurting yourself. White skin is intimidating. No sooner tanned than you blend with the trees, with the animals; you no longer dare dress. I would go off with a gun (this being with me an atavism; I do not kill, I shoot pine cones) and I would cross the brush. The soft sand burns your feet like embers. The ocean thunders behind three dunes without footprints save those I left the day before; it heaves into sight. You could hear its waves many miles away. They break on the beach and shoulder each other, grinding a pearly powder that marks out the water's bottom from right to left. My dogs bathe, I bathe. Lying in the sun, with not one detail to betray the epoch, I float on my back over the ages.

New scene: Ahusky. A village which is an inn. What is a Basque village? A church, a handball court, an inn. At the Ahusky inn an ancient barn has become a chapel; a wall, a handball court. I had to build my table out of boards. There is not a single tree. You meet only the bones of dead cattle. Vultures swim in a lake of air at the bottom

of which you descry the valleys. Sheep flocks stand out on the rocky mountainside and bleat. These lamentations, these pale profiles, this wool, those eyes —it all makes you think of the Jewish people. The shepherds do not speak any language, they bark. Ahusky's spring is renowned; its water gets rid of bile. People come from the four corners of the earth to gather it in jugs. Since it flows drop by drop, the women wait. People talk, camp out, sleep around it. The spring becomes a shrine.

Right here in Villefranche, every evening, I sit alone in the harbor. The routine is sweet. A star lights up on the right, another will light up above Saint-Jean. I well know the order in which the stars light up; between the first and the second an old man passes with a goat on a leash. The rowboats knock against one another, the lighthouse moves its megaphone about over the sea. As fishermen talk to me without seeing the death that hems me in, I have the illusion of living.

Such things put at ease my spirit decked in Sunday garb by my intelligence. In Paris I seem as if I know; this role kills me. I think of nothing but fleeing public places.

What has brought me into contact with certain

luxuries and certain sensational doings is the fact that it is folly to want to have country nerves in the city. The city—this neuropath—forces me quickly to leave; it leaves the heart out of account. This is what Max Jacob meant when, sending a young poet to me, he advised me: "Make him into a peasant like us." The more I think of it, the more I feel that this earth, tilled by the peasants he speaks of, by the fish out of water I spoke of, is Heaven. Yes, we are the clumsy ones of Heaven. Poetry is just the country accent of where we hail from.

Is weakness a defect? It remains that yours looks like alabaster lit up from the inside. Your soul transforms defects into beauty. You who are transparent, a soul disguised in a body, a face imprinted in a cloth, your weakness is a fearful strength, the strength of a plowman. I have just had the proof of it. Do not deny it. Like a fool I was hesitating on the brink of Heaven. Max Jacob was praying that I fall in; Reverdy was getting angry. And you pushed me—pushed me like a man who kills. You knew I could not swim, but you knew what the instinct of conservation was capable of, especially when it goes beyond the desire to live and it is a

question of saving your soul instead of your skin. ⅃
I shall speak again later of this assault.[1]

God Wants Me

I lost my seven best friends. This is as much as
to say that God, seven times, bestowed graces on
me without my noticing. He would send me a
friendship, take it from me, send me another, and
so on. Seven times He threw His line and drew
it out without catching me. I would let go of the
bait and fall stupidly back in again. Don't go and
think He was sacrificing youth; He was dressing
up angels. An illness or war serves them with a pre-
text to undress.

You know what I call "gloves of Heaven." To
touch us without soiling itself Heaven sometimes
puts on gloves. Raymond Radiguet was a glove of
Heaven. His form fitted Heaven like a glove.
When Heaven takes out its hand, it is death. To
take this death for a real death would be to con-
fuse an empty glove with a cut-off hand.

[1] You had an accomplice: your wife, who looks like a
gossamer thread, and who is a soldier of Christ.

I was therefore on my guard. I had seen at once that Radiguet was lent, that he would have to be returned. But I wanted to play dumb, to steer him away at any cost from his vocation for death.[1]

It was a useless ruse. Thinking I was weighing him down by taking books away from him, I was making him lighter. With every book removed I would see him float far out, sink down, go toward a mystery with which he visibly had rendez-vous.

In the summer I would take him to the country(2); he became a good child, he wrote in school copybooks. Sometimes he would rebel against his work, as a schoolboy rebels against his holiday homework. I would have to scold him, to lock him up. Then he would angrily throw a chapter together. After that he did it over again.

Winter in the city was frightful. Why did I beg him, alter my life, try to set an example for him? Debts, alcohol, insomnia, piles of soiled clothing and flights from hotel to hotel, from scene of crime to scene of crime, made up the principle of his metamorphosis. This metamorphosis took place in

[1] The struggle sometimes seemed impossible. Romain Rolland wrote me concerning *Le Bal*: "After having sunk such a claw into life, how can one let go?"

the sanatorium in the rue Piccini, on December 12, 1923.

This time God's line was pulling me out. I let go half way up, letting a mere half of myself be raised up. It was in this state that you came to know me. My transparency was far from resembling yours; yet it took from me the thicknesses that demoralize you. We mingled without effort.

This misfortune brings to a close a long period during which, with a group of musicians, and under the patronage of Erik Satie, I unbewitched French music. It had been dying under magic spells. Satie set an example of a musical saint. (Thanks to you, Maritain, he died a Christian death.) This unbelievable man used to make faces at himself. He was afraid of falling into the fault of the masters: of finding his works beautiful and being stirred by it. We saw him substitute form for the reflection of forms, and teach us that what is great cannot look great, what is new cannot look new, what is naïve cannot look naïve. He taught us that true artists were amateurs, that is to say, men— according to the perfect definition of the Larousse —"who love poetry without making a profession

out of it." With his finger he would point, as an old guide points to the peaks in the Alps, to the chain of amateurs bound together by the chaos of the professionals. He would give us the key to dreams and the program for our task. Radiguet came to my aid. We had to make some forms lose their stiffness and greenness [1]: the comic, gracefulness, tragedy, the novel, the theater. To this Radiguet added advertising. He saw in it a new way of putting in a bad light works that might please too quickly.

At our weekly Saturday dinners (they took place for four years: 1919–20–21–22), Radiguet would play the part of a young chess prodigy. Without opening his mouth, solely with the contempt of his near-sighted eyes, of his ill-cut hair, of his chapped lips, he beat us all. Shall I call to mind that the greatest players sat down around that table(3)?

Each of his movements indicated one of those profound successes that are come by through neglecting the recipes for power.

He was hard; diamond was necessary to take hold of his heart. He was accused of dryness as they accused Madame de la Fayette. Excuse me if

[1] "Il s'agissait de déniaiser certains styles . . ." *Tr.*

I keep coming back to it, but as you know, it is one of my sorrows that you never knew him.

The title of my address to the Collège de France in 1923, *d'Un Ordre Considéré Comme Une Anarchie,* sums up the spirit of a meteor of laughs, scandals, pamphlets, weekly dinners, drums, strong drinks, tears, mournings, births and dreams that amazed Paris between 1918 and 1923.

Romeo

Radiguet's death operated on me without chloroform. I was taken away to Monte-Carlo, where I witnessed the success of the *Biches* of Poulenc, and the *Fâcheux* of Auric. On my return the Count of Beaumont, with a view to getting my mind off my sorrow, made me start the production of *Roméo et Juliette.* The text had existed since 1916. I tried on it, before doing as much for *Antigone,* an operation to rejuvenate great works, to piece them together, to make them taut again, to remove their patina, the dead matter; in short, according to Stravinsky's answer, who was being reproached for his disrespect for Pergolesi: "You respect, I love," I wanted to marry them(4).

What a dazzling nightmare, those shows at the Cigale! Backstage, even during a play that gives an impression of calm, it is a sinking ship. Madness and nerves inhabit the shadows where the crew of comedians, scene-shifters, dressers press together in silence. I had the part of Mercutio. My dressing-room was separated from the stage by just a corridor. The bagpipe orchestra stressing certain passages would reach my ears and agitated me. I wept with weariness. I slept standing. My friends pushed me onto the stage like an animal.

My dresser had the habit of saying: "Before the death of Monsieur Jean" or "After the death of Monsieur Jean," and true it is, I have never played the duel scene without hoping my pantomime would deceive death, and would decide it to take me.

Thus, two months of labor day and night, sadness, medicines swallowed pell-mell made me into an insect whose shell was the costume of Jean Hugo.[1] Had I been cut in two like a wasp, I would have kept on living, shaking my painted collarette and my legs. For I am hard to kill. I've got to be— to stand such things.

[1] Designed by Jean Victor-Hugo. *Tr.*

I begged for mercy. It was so simple to ask for Grace. Like the people of Nice, whose shutters are a part of the great letters of a billboard advertisement, I lived in God and had never come out to see my window from the outside.

An evil force kept on ruining me. Before me I would see dryness, memories. I announced my silence until further notice,[1] thinking to give to the word order its supernatural meaning. In short, I found myself in the anguish of a runner who does not distribute his strength well, and breaks down half way.

Opium

"Confess and commune," Max Jacob said to me. "What?" I wrote to him in Saint-Benoît,[2] "you are recommending the Host to me as you would an aspirin," and he answered: "The Host must be taken like an aspirin."

I call forth the angel of one of his poems, angry to see him so silly. It is Max's turn to be the angel

[1] "J'annonçai mon silence jusqu'à nouvel ordre . . ." *Tr.*
[2] St.-Benoît-sur-Loire, a village near Orléans. *Tr.*

and to get angry with me. Is it possible I have not recognized, applied to souls, the regimen I recommend to minds?[1] There I was Wagnerian. I was being offered the snow that flies, altar bread, the enchanted bread.[2] But I, who always balk at Orientalism, chose the flying carpet.

My dear Jacques, your patience is without limits. It allows that a man, worn out by tasks that submerge him, and by mourning, let himself go off to sleep. For a long time slumber was my refuge. The prospect of waking up prevented me from sleeping well, and influenced my dreams. In the morning I no longer had the courage to unfold life. Reality and dreams became confused, making an unclean stain. I would get up, shave, dress with people in my room, and I would let myself be dragged off anywhere.

Oh, those mornings! You are pitched into dirty water and you must swim. In that state the reading of a newspaper is unbearable. This testimony of universal activity, and of those who write it up,

[1] *And Pascal's advice.*
[2] "On m'offrait neige qui vole, le pain à chanter, le pain enchanté." *Tr.*

kills you. My flight into opium was Freud's *Flucht in die Krankheit*.

Opium must not be confused with drugs. Never have I smoked it in the company of those who compromise it. A real smoker, seeing me suffer too much, handed me his pipe.

You do not try opium. You cannot play with it; it weds you(5). The first contact is deceiving. The benefits come only after a time, and beatitude makes itself known when it is too late to abandon it. I put more effort into getting into the habit of it than into getting out of it. The smoke made me sick. It took me nearly three months of nausea to get used to the pitch and roll of the aërial carpet. I stuck to it; I could no more accept the discredit literature throws on opium than the ridicule to which the snobs expose us.[1] I do not regret the experience, and I maintain that opium, if its handling were not a matter of such extraordinary deli-

[1] Just as real painters do not take any useless equipment with them, so the real smoker does not use fancy pipes. He smokes an old bamboo, with a minimum of utensils. To the Benares, which is the opium fiend's de luxe tobacco, he prefers a drug that corresponds to the caporal.[2]

[2] Cheap popular French tobacco. *Tr.*

cacy, could prepare many souls to rise. The difficulty is in sensing where it ceases to be charitable.

(One of its tricks, which it would be inaccurate to attribute to anesthesia, is to make the sense of touch blossom to the point where we are convinced the touched object is one with us. A finger falling from the hand of the smoker would surprise him no more than the cigarette he lets drop because it was burning his clothes.)

Does opium force specious reasons upon us for its defense, or does it give us a clairvoyance that disappears in the normal state?

When I came to where I could not do without its noble rites, I realized that prejudice against opium was romanticism; the prejudice of discomfort. Since a remedy that acts on the sympathetic nerve suppresses moral pain, or transfigures it to the point of making it sweet, there is therefore no moral pain, and this famous moral pain is nothing more than physical pain. This brought me to the conclusion that it is mad to go to the dentist and to reject the aid of opium. Why, the Lorelei kept murmuring to me, why is it fine to suffer? Only mediocre poets profit from suffering; the great ones produced only when serene.

You see the trick: opium upholsters us, it carries us upon the river of the dead, it disembodies us until it makes us become a light meadow; the night of the body swarms with stars, but our bliss is a bliss in a mirror. From head to toe we become a lie. We become mummified; the factory goes to sleep. The organism will not obey; varying temperatures and annoyance do not touch us; we feel neither cold nor heat.

Neapolitan painters decorate hotel rooms with *trompe-l'oeils*; [1] opium is a painter of trompe-l'esprits. It plasters up with them the walls of the room where I smoke—all of them catering to my yearnings. Two and two no longer make four; two and two make twenty-two. A disquieting sense of well-being takes hold of you. Anxiety, there's our weak point. Opium is quietude. The moment worry steps in, you're lost.

The Chinese smoke little and move little. They do not ask exceptional services from the drug. They respect it and leave it free to extend its waves. As for us, coarse characters, we want to draw from it the means for an agitation it hates and

[1] Still life painted in such realistic detail that for a moment it seems the real thing. *Tr.*

that it will always punish. China smokes to draw close to her dead. Invisibility is the result of a motionless speed, of speed in itself. Opium resembles this speed of velvet. Will the dead only slow down, a meeting zone is formed. Life and death remain as far from each other as heads and tails on a coin, but opium passes through the coin.

The Chinese also use opium for less noble ends; they make unequal the chances of trafficking by offering a courtesy pipe to Europeans they want to take in.

On the whole the effects of opium vary. Opium is a nerve regulator. It adds what is lacking. It applies cork to some, and lead to others. With me it was lead. This diver's suit prevented me from floating adrift, and gave me a positive sense of contacts. Never does opium give rise to visions. At most it sends the switchman to sleep. The junctions are manoeuvered haphazardly. The mind slides down any slope. You go up it again, and the mind, to its surprise, finds itself very far from its starting point. Sometimes it manages to overcome opium's resistance; it unravels a trite idea. The drug then has the distorting action of water through which Negro

divers descend with the complicated majesty of Indian ink.

These phenomena happen when you smoke alone and close your eyes. In company the effect is scattered. But enough is left to create confidence around the lamp, to bring people with little in common to the same temperature (6).

But I repeat, in Europe we do not know how to smoke. We do not accept the malaises that the healthy man accepts; we increase the doses. Should the awakenings be painful, we smoke in the morning; and should it be difficult to smoke at home, we eat the drug. Eating snarls you up in the reckoning. Twelve pipes are needed to procure the effect of one pill, for in eating you absorb the morphine and the dross.[1] The troubles begin: shimmering perspirations, icy siphons, yawning, nasal mucus, paralysis of speech, knots in the solar plexus. I confess not to have known these symptoms well. I was seeking suicide and I absorbed massive doses. But he does not kill himself who will. The optimism which this prison here below gives us counseled me

[1] One cannot describe the *need* to those who have not felt it. The others hardly want to be reminded of the sparkling anxiety of the animal fluid.

to get out of it. Suicide is cheating. Cheating is impossible for us awkward ones. In short, I am thrown out of the Suicide Club for not having known how to cheat.

That is the dodge thanks to which I made myself a prisoner, in the rue de Chateaubriand, at the *Thermes Urbains*, where you were the first visit I received after sixty days tête-à-tête with my nurse.[1]

Let me hand you the diary of a disintoxication: showers, electric baths, nervous systems in astrakhan, crazy legs that would like to walk on the ceiling, to the building across the street.

Opium resembles religion insofar as a magician resembles Jesus. It conjures away suffering. Suffering waits in hiding. You can imagine the confusion of the veins and soul as they find, new as ever, these sufferings garaged away for a year. Yet never did the doctors Capmas, Dereck and Marion-Landais manage to make me speak against opium. I insist. It is not I who left it; undoubtedly *it* ceased to want me.

This chaste drug becomes a crime with us. It

[1] The *Thermes* no longer exist. The first blow of the pick was given the day after I left. Then I saw, from the home of my friends the Hugos, who lived opposite, my room cut in half, abstracted, flow away!

happens that it develops the evangelical qualities of one's being. It could fill us artificially with the beatitudes that raise up the monk, and it could help us vanquish the senses. It would then become the prelude to a genuine self-elevation; the link between a brutal life and a spiritual one. Its departure awakens your coarseness. A faun emerges from cotton wool. You were perfectly happy without it. The resurrection of the schoolboy is, alas, the first sign of a return to normality.

The demon of curiosity questions me: And what about the senses? the dumbfounded senses? the misinterpretations? and what about the skin troubles, the transports in common? and the funeral rites? and the vices and the vice-changers? [1]

[1] The translator can no longer keep himself from hopping on stage, his hands held out in placation, and announcing that if certain parts of this letter sound like a piano out of tune, they do so as well in the original. Granted that this is not generally the case. Cocteau's style is electric with allusions, with poetic puns, with original and ingenious strainings of the French language; one seeks to convey the central idea and the current runs out. For example: "Mais nous sommes pays; c'est-à-dire, nous sommes deux dépaysés de la même espèce" (But we are countrymen; that is to say, we are two fish out of water of the same kind). "Je demandai grâce. Il était si simple de demander la Grâce" (I begged for mercy. It was so simple

Ever since high school I have lost my head over the birth of Venus. This piece of mythology now bores me. Radiguet [1] carefully warns us not to confuse it with the birth of love.

When leaving the *Thermes* I was neither proud nor pleased with myself, but I could feel that my pain was pleased. She does not like you to forget her, and my sort of person appeals to her.

to ask for Grace). But then a few parts are obscure in the original: "Je comptai sur nos pauvres limites pour suppléer à celles qu'un homme fort décide lui-même" (I was counting on our paltry limitations to make up for those that a strong man decides on himself). And other parts, though not undecipherable, mean something so far-fetched and, let us utter the word, smart-aleck, that there's no translating of them in a way that will make sense in English. A case in point is the present paragraph, which in French reads: "Le démon de l'enquête me questionne: Et les sens? les sens interdits? les contresens? et les affections de peau, les transports en commun? et les transports funèbres ? et les vices et tourne-vices?" Aside from the translation given above, this passage contains the following intended meanings: ". . . And what about the directions [the meanings]? the one-way streets [the forbidden meanings]? . . . and what about the skin troubles [the fleshly affections], the transports in common [*i.e.,* the Paris bus system; the shared rapture experienced in the practice of vice]? the paroxysms of grief? the moral vices [but also, 'les vis,' the screws] and the vice-hiders [vice-changers; screwdrivers]?" Pass me the aspirin. *Tr.*

[1] This mentor of Cocteau's died at twenty. *Tr.*

The Secret of Beauty or A Soul in Slow Motion

After my convalescence at Versailles, without reaching out a pole for me to take, without a shadow of proselytizing, you let me share your work (7); you started a series which Plon published, a meeting place for writers of different backgrounds but of the same caste. One evening several of us gathered at your place to talk about it. Souls are sorry organizers; one could have taken us for children pretending to be grownups.

You had announced a possible visit from Father Charles. I know nothing of him, except that he wore Father de Foucauld's robe and lived in the African desert as a hermit. I also knew he had met Claudel when landing in Marseille (Claudel was in Aix for the marriage of Darius Milhaud), that he would spend a week or so in Paris, one or two months in the Vosges, and that he would return to his place of prayer: a little hut in the midst of sands.

Lightning is disconcerting. Sometimes it can be a very light red ball which comes into a room, moves about, and leaves without harming anyone.

Jacques, was this your trap? Were you awaiting this minute? A heart [1] entered the room; a red heart surmounted by a red cross in the middle of a white form that glided about, bowed, spoke, shook hands. This heart hypnotized me, distracted me from the face, beheaded the Arab's robe. It was the real face of the white form, and Charles seemed to hold his head against his breast like a martyr. And indeed the real head, burned by the sun, seemed a reflection of the heart, a mirage in all that African light. The cheekbones and the chin outlined the mirage's reliefs and tip. Then I distinguished a glance badly focused for short distances, and the hands of a blind man; I mean hands that see.

Let me not bother you by going on with this. I am coming to what matters: the ease of this man. In the face of it, what became of mine? the charm of a ham. He, smiling, talking, reminisced with Massis. I, stupid, groggy, as boxers say, was looking through a thick pane at the white thing moving in the depths of the sky.

I suppose your wife and guests must have

[1] The red heart woven on the front of the white hermits' robes. *Tr.*

noticed; room, books, friends, nothing existed any more (8).

It was then, Maritain, that you pushed me. Pushed me in the back by a blow from your soul, which is an athlete; pushed head first. All saw that I was losing my balance. Nobody came to my rescue, for they knew that to help me would have been to lose me. Thus I learned of the spirit of this family, which Faith brings to us instantaneously, and which is not one of the least of the graces of God.

After the first spasm of the fall upside down, things take care of themselves. Falling from Heaven mows through the guts; falling into Heaven grasps hold of the heart.

The Earth is a demanding mother; she hates us to leave her. She tries to get us back at any cost; sometimes she does not hesitate to take an aviator by main force. But Heaven leaves us free to undergo or not to undergo its attraction.

Do you know the underwater film of the Williamson brothers? Despite the orchestra's polka, Negroes, deep sea divers, women swimmers, sea weeds and octopuses live in a silence where our

laws have no more sway. Already this retarder, water, seems to imprint a supernatural style upon the things that move in it, but the invention of the mechanical retarder shows that we must always go beyond. This submarine majesty is but a rough beginning. Here, seeing it in slow motion, our hearts stop beating before the silence of silences, the grace of graces, the slowness of slownesses. I always advise a short slowness to young writers. Water and the camera combine to form this heavy lightness, compared to which any other movement seems vile. For no agitation resists. Plunge it into this developer: vulgarity, ridiculousness melt, they are translated into an idiom capable of moving me.[1]

Slow-motion pictures have made me understand that everything is a question of speed. See a football [2] game. Thirty brutes become the smoke of a cigar.

[1] When, by virtue of this changing of speed—that we lack and that motion pictures enable us to conceive—a horse race separates into its elements with the magnificence of a cloud changing shapes, the audience laughs. This laugh is a proof of the mirth that would be aroused in a mob by the exact vision of the purest movements of the mind and the heart.

[2] For English readers: rugby. *Tr.*

Nothing intrigues me more than this angel that slow-motion forces to emerge from all things, as a chestnut from its barbs. What? Since in relation to God our centuries last the space of a twinkling of an eye, we are filmed in slow-motion. So a little less speed would unravel our souls, take away the ferocity from human intercourse. Suddenly I understand Charles' secret of beauty, and I remember the saying: "God is patient because He is eternal."

I am mistaken again. There is zeal in the hope of a reward. Here I am contemplating prayer made man. His hunger to live and to survive sleeps the fakir's sleep. He inhabits the below-stage of the theater, the machinery of which juggles away an absent-minded person. His ability to appear and disappear is the opposite of our absent-mindedness.[1] A priest struck me with the same shock as Stravinsky and Picasso. Thus he furnishes me with a proof of God's existence, for Picasso and Stravinsky know how to cover the paper with divine signs, but the Host is the only masterpiece Charles offers me. Would his gesture tear me from myself if he presented me with only a blank piece of paper?

[1] Saint John of the Cross teaches these exercises with the precision of a swimming master.

The School of the Undesirables

Already nobility of soul plays the part of heavy water and calms the puppet, but without Faith it is a superficial retarder.

What surprises at first! We occupied ourselves and we are occupied, occupied by the friend like a region occupied by the enemy. God takes care of everything, and it is that which upsets our pride. Claudel writes me: "As it has been for not a few of us, the acclimatization period of the new man may be rather disagreeable to you." I answered him that I had the embarrassment of treading on the Blessed Virgin's robes at every step.

Yes, one stumbles. The air is too pure, and threatens to send him to sleep who does not rise little by little.

The morning of the Feast of the Sacred Heart of Jesus, in your chapel, in the midst of some of your intimates, Father Charles gave me Communion.

After the ceremony we took up again our usual relations. Nothing marked the difference unless, now and then, a glance from you upon me, a quick

sounding, what cod fishers call "making the blue pigeon fly."[1]

What did you see?

To such a point was I alone, jilted, disabled, that one of my friends, a Jew, asked for the grace of conversion in order to be with me again. (He was baptized in your chapel, on the 29th of August.[2]) Then it was that you did something adorable. Barrès thanks Bourget for having given him a public. You gave me something better: companions. Many young men asked, and still ask, your help. You sent them to me; you sent them one by one.

Before this period, something chemically necessary to the taste for life did not combine with the rest of me. This lack of moral appetite was dreadful; no plan was appetizing to me. My soul was nauseated. The young men I saw played at committing suicide, crimes, at disdaining values. Sleep was my last refuge. Coming out of sleep was death. Help came to me in the nick of time.

Poetry is a machine that manufactures love. Its

[1] That is, casting the plumb line. *Tr.*

[2] And in January he entered the Seminary of the Carmelites [the Seminary of Paris, formerly a Carmelite convent; *tr.*].

other virtues escape me. Admirers touch me little; they admire me together with this and that.

But what can I offer to hearts mad about poetry, in exchange for the service they render me? Some of them come to me from Maurras. "An honest man examines himself . . ." he writes in a famous sentence from *Anthinea*. Is Maurras still examining himself? I always see him hurting himself on the angles. Curves excite him. He kisses a dead column [1] that can no longer bite. He deserves to have this column turn into a girl and address him thus: "What are you doing, sir? Have you nobody you can kiss at home?"

To kiss neither an Athenian column nor a New York factory chimney, that is the program I offer. I should like to make a school of undesirables such as myself. I would teach there the attitudes that close all the doors to you. What do you think of it (9)?

Avid young men, believe me. There are but two ways to win a game: to play heart [2] or to cheat. Cheating is difficult. A cheater who is caught is

[1] On a trip to Athens Maurras once kissed a column of the Parthenon. *Tr.*

[2] To play a heart (a playing card) in the game of hearts. *Tr.*

beaten. The great race of scoundrels is never caught; they are the men in power, the state ministers, the famous painters, poets, novelists, musicians, comedians. I admire them. How could I admire a scoundrel sentenced to hard labor? He failed.

Playing heart is simple. All that's needed is to have a heart. You think yourself without heart. You study your cards badly. Your heart hides itself for fear of ridicule, and in obedience to an old criminal code: "Here comes the time for murderers (10)." Exhibit your heart and you will win. Here comes the time for love.[1]

Necessity for Scandal

It is a serious error to take conventionalism for a kind of humility. God will not stand for any kind of lukewarmness. He demands silence or boldness. All I know that suit Him are extreme art and the Orders. Levitation is His proof of love. He is not lavish with it. But occasionally He raises up a monk or a poet.

[1] Wickedness has served too long; it wears out. Goodness, being perfectly new, allows astonishing combinations.

Heaven would shock the Earth. It is enough to contemplate the gait to Jesus to realize that Heaven could not be official. Jesus refuses to make a career. He wants to be born and to die every minute. Our crusade will be to shock out of love (11).

I have never caused scandal without premeditation. I deem it indispensable. I give sleepers a dousing. The last big theater scandals were those of *Parade* and *Les Mariés*. After that came the scandal of silence, when we were thinking of setting up a new order. *"A little simple for me,"* said a lady on coming out from *Les Biches* of Poulenc.

Already *Mavra*, by Stravinsky, had left the audience frozen (12). From him I learn that Pushkin, having written *Mavra* at the end of his life, loaded with honors, got the same reception. People felt he was making a mistake; the public never gives anyone any credit.

The public, which we trained, is no longer made angry by anything. It insists that one walk on one's head. Doubtless order is now shocking, but without raising one of those storms that freshen the air.

I should like intelligence to be taken away from the devil and returned to God; I should like to re-

lease into a rather warm and holy dimness, choir boys, pirates of scruples, believing in God and the Devil and capable of everything.

Aiming so high frightens you perhaps, but as you know, I flatter nothing, I hide nothing; I am confessing. I have let my civic sense lie fallow; my justice is therefore formed without prejudice. Now instinct always pushes me against law. This is the secret reason why I translated *Antigone*. I would hate to have my love for order benefit from the meaning that is idly lent to that word.

I, who don't bother about politics and don't look at newspapers, feel pleased at some seditious acquittals. Through this obscure testimony I must salute, in its least high form, an unforeseen force opposed to Creon,[1] to the foreseen mechanism of the law.

I remember a photograph in the newspaper *Excelsior*. It showed Greek generals awaiting the verdict. The distance between the fatuity of their rank and their sentence of death was too great for them to encompass. They were smiling. Behind them the

[1] Uncle of Antigone and tyrant of Thebes. Having forbidden his niece to perform funeral rites over Polynices, her slain brother, and been disobeyed, he had her put to death. *Tr.*

crowd knew; you could read it on their faces. This surprising picture satisfied something hard in me—who would not hurt a fly.

For instance, I consider the Russian revolution as the only significant result of the World War, the only point in Europe where the vaccination took. I refuse absolutely to criticize a people that changes its skin.[1]

Now, I shall be precise. Art and politics do not go at the same speed. The art of a country during a revolution is the revolution itself.

Revolution relegates poets to the rank of orators, it demands a garish boldness, posters, tracts, faces on a coin. One must not confuse the poetry of a revolution with a revolution in poetry. A revolution in poetry can only occur in a country free from internal wars. France has just been the secret scene of a formidable poetic revolution. Order after a crisis, that is the new order I insist upon. This is why I am hated by the profiteers of disorder, and why I cannot be heard by people for whom order must echo some older order.

[1] My friendship for Robespierre and Saint-Just is well-known. Alas, imitating their doings is opposed to the basic principle of revolution.

Art according to art! Love according to love! This is taking the salt away from Heaven. Do you think Our Savior tries to make Himself talked about? He does not ask to be recopied. God cannot be deified without ridicule. He likes to be lived. Dead languages are dead. One must translate Him into all the living languages, and help Him to hide Himself to do good just as the Devil hides himself to do evil.

I look at the sea, the sky, the stars, this solid ball where our smallness makes us see limitless distances. We live on an object at God's. The marvel of it is that He concerns Himself with the tiniest detail of one of the atoms whose swarming makes up the matter of this or that object.

But if He counts us, if He counts our hairs, He counts also the syllables of poems. Everything is His, everything is from Him. He is boldness itself. He has endured the worst insults. He asks for neither religious art nor Catholic art. We are His poets, His painters, His photographers, His musicians.

Art for God

A sentence of Father Charles struck me: *"Re-
main free."* Indeed, why alter my voice? Ever since
the *Potomak* my care has been to set in order a mad
disorder, to subdue romanticism, to kill the vir-
tuoso,[1] to make out of my weakness a spout like the
stream with which Americans cut into granite.[2] I
have no complaints concerning this search for a
straight line since it leads me to the line of lines, the
melody of silence: the Blessed Virgin, and to the
classicism of mystery: God. People will ask me:
"And what about mysticism?" I agree, religion has
a little of everything. But this aspect of it danger-
ously resembles the devils that want my ruin.[3]

Since 1913 I was living and dying from mystery
out of order. The *Potomak* proves it. During that
period I practised dreaming. I had read that sugar
makes one dream; I ate boxes of it. I would go to

[1] That is why I refuse to do articles and give lectures,
even when it pains me, and when it is foreign students who
call me.

[2] These streams are used to wash out not granite but
free gold in placer mining. *Tr.*

[3] Sainte Thérèse de Lisieux says: *"To all the ecstasies
I prefer sacrifice."* Poets should have these words tattooed
on their hearts.

bed all dressed twice a day. I would plug my ears with wax to make my dreams take root farther than in outside noises. *Le Cap de Bonne Espérance, le Grand Ecart, Thomas l'Imposteur* are ghost stories. Even when a child, a storm ravished me like a caress from Heaven. I would announce it the night before. I became the scene of its preparations. The lightning would send me into an ecstasy. This ecstasy would be dispelled with the first drops of water.

Before discovering this so simple thing: God, the order of mystery, what a disorder I went through! What traps I did not build! Mystery was my fixed idea. I imagined it careful never to give itself away. I watched for its least weakness. In the end my traps were always Vaucanson's [1] duck or Maelzel's chess player.

I tried very little hypnosis or table turning; I preferred exhausting speculations: ambushes, playing truant, special watching places. My friend Garros had discovered in my house, thanks to a photograph behind a fan, the principle of shooting through the propeller. I, in my turn, was dreaming

[1] Vaucanson was an 18th century maker of human and animal automatons. *Tr.*

of a fan going beyond the accepted speed. A motionless speed that would hum no more, blow no more, cut no more, a monotonous limitlessness. The invisible became for me this speed. You can guess my expectancy: something breaks, and an angel appears.

Often I repeated to myself: we are the mystery of mystery. It divines us; it does not see us. Ghosts are the awkward proofs of its efforts. A prodigy is not a blunder of Heaven but the result of a science that seeks. Then the malignity of the invisible would once more become a fact for me.

At the movies I no longer looked at the screen. I was learning to read, in the overhead beam of light, the rays that knit about each other. I came to where I could tell a closing door, a hand doffing its glove, a brawl. But it was the Braille system. Pictures, in the dimension of length, are dead letters to us. We can see them only in slices, at some point in the bundle of rays. I hoped to discover a segment of the invisible, a slice of mystery, a way to unmask it against a wall.

We are not far from what in the country they call "teasing the Muse." A song from *Le Cap* ends with: *I am teasing eternity*. Teasing an angel is un-

wise; often he turns away like a tall, gentle woman who does not want to be kissed; and on a sudden he strikes. For, to use children's language: "God lets us play with His things." Science is the result. But there are also badly brought up children who are liable to bite their fingers.

These efforts at evasion left my soul jumbled. Weariness saved me; I wept, I hid myself at the seaside, I drew and quartered myself in the sun, I dreamt of calmness and of living happily. I formed within myself an ideal of joy.

An ideal of joy! This ideal, given plastic form, would I have but accorded a glance to it? Perhaps through the vice that makes us like certain colored postcards. For what strikes us as a piece of bad luck, as an aptitude for drama, makes somewhere else a masterpiece. Our injustice comes from short-sightedness. What does the canvas think on which Picasso is painting? "He is spotting me, he is hiding me, he is soiling me."

My laziness likes to receive orders. From whom would I consent to receive them unless it be God? It is not mysticism that convinced me. Miracles, I

adore them, but they rather interfere with me, as any proof does. What convinces an undecided intelligence is the skeleton of our religion, its figures, its algebra of love.

What can be more doltish, more fuzzy than 18th century skepticism? One does not hate it; one enjoys it as an attitude of mind, an attitude that, with the advent of science, quickly became the climax of vulgarity.[1] The great discoveries of man are flotsam brought in by the waves. Never yet, in the domain of the supernatural, has he met with an America. And these are the paltry seashells where he listens to God without hearing Him; where he believes he is hearing himself. Here is the literature of 19th century freethinkers. Here is all literature. So?

Literature is impossible. One must get out of it. It is useless to try to get out of it through literature; only love and Faith enable us to get out of ourselves. To resort to dreams is not to leave home;

[1] It can happen that Heaven builds an ark on this flood of dryness, and ships into it, together with all its animals, a family with a great heart like the Berthelots. A family of unbelievers but possessing—isn't that so, Claudel?—the virtues given by Faith.

it is searching the attic, where our childhood made contact with poetry.

Art for art's sake, or for the people are equally absurd. I propose art for God.

Imagine, my dear Jacques, the joy of a language freed from Rimbaud (at present, a more encumbering figure than Hugo), and of the superstition of Maldoror. Youth would be able to breathe.

What am I saying? I am very shy. This letter still stinks of sacred dust. In it I denounce art according to art; I forgot what is most important: man is a work of God. A work which produces works, that is the limit! Fluid is expended at third hand.

Why carom with this strength [1] of persuasion that God gives us, and which is nothing other than Himself? I am beginning to grow tired of Beauty's not being able to take it in the face of varying fortunes. I imagine an era where the mind, abandoning its awkward vehicles, would give up trying to convince by means of works of art. Beauty would gradually become goodness, masterpieces acts from the heart, genius would become sanctity. A vast

[1] "Pourquoi jouer par la bande cette force . . ." By this billiard term Cocteau means: Why use indirectly . . . *Tr.*

enterprise of small and large hypnoses would banish trafficking. Books, canvases, oils and ink would disappear as cab horses have. The strong man would show the volume of his mind as precisely and instantaneously as the fakir shows his rose bush; old cameras could no longer photograph our divine tricks. I touch the future with heavenly fingers. Some day it will no longer be a question of deceiving birds, not even cubist birds, but of training birds to eat an unreal grape.

Previous to this year, incapable of hatred or rancor, I was trying to determine my position regarding my opponents (you know whom I mean [1]), for you fall into a great solitude when you must defend your opponents before people whose alliance you will not have, and who possess none of the high qualities necessary to undertake their trial.

Avoid them? How can I avoid them? This painter, this poet, this photographer, that revolt make up our inevitable meeting places. And then a negative resemblance exists between them who, too wide awake, try to break into the world of

[1] The Surrealist poets. *Tr.*

dreams, and I who sleep standing, and who try to break into the world of reality.

A Poet walks with his feet in the sky; they simulate this power by a play of mirrors. But that does not prevent me from placing their spells far higher than present-day poetic productions.[1]

People will remind me that I advocate a certain injustice; they will reproach me for my excess of scruples, for an idiotic elegance apt to mix up the world—which tars all of us with the same brush. If truth pleads in behalf of falsity, how can you tell which is which? It is simple: let your bees go, you will see on whom they light.

Today my attitude is changing. I am no longer seeking it. We love our enemies. How could I have contempt for these spiteful friends who bruise themselves against death?

No More Bets

Ah! my dear Maritain, I know badly how to make myself understood. A transition weighs on me. A look of incoherence suits me better than to

[1] I make the exception of a poet and a painter who know how to walk upside down.

be perpetually shading off from color to color. Books like *Le Coq et l'Arlequin, Visite à Barrès, le Secret Professionel,* or this present letter are but the match of a fireworksman. I walk at the foot of nocturnal scaffoldings. Unknown young friends darkly pack firecrackers which they dare not touch off; and now with what joy I myself touch them off for, as well as I do, you know the name that shall write itself amid the crackling explosions.

That is my role. I stick to it. It is I who should adopt your motto: "I am an ass and I carry the Lord." For God will have nothing to do with adroitness. Would that I only could, while praising Him, preserve my manner, remain free as Charles advised, not fearing to put my foot in it!

Motion sleeps in the midst of a turning wheel. The farther you go from the center the more you find yourself swept along. It sometimes happens that a soul in Italy is not moved by Rome, and lets itself be convinced by Assisi. That is the chance a small book runs. *Le Coq et l'Arlequin* was rotating far from the musical center. Because of this it swept along many people. Those who did not see the urgency of this work written on two notes, like the fire engine's call, and who thought it was the

work of a thinker, found it naïve. On the other
hand the technicians of music reproached me for
not speaking their language. It would have been
easy for me to surprise them. Honegger or Mil-
haud, Poulenc or Auric would have furnished me
with the technical terms. Alas, I had to act fast,
shout loud. That is my excuse for this childish
letter.

I shall endure without shame the smile of theo-
logians, if it will only stimulate a few young Cath-
olics.

The place where extreme right and extreme
left touch each other still remains to be taken. Is
there a more exciting, more risky program than
following Christianity to the letter? I add: than
shaking the hand of our Jewish comrades?

Barrès was lucky. As for me, my dead are in
Montmartre; my Lorraine is a street. I had to
seek out my road up in the air. This tightrope
leads me to Catholicism, that is, home; it is there-
fore false to speak of conversion. Yet how could I
avoid shocking people? The manners of an acro-
bat are not to be shed in one day.

I shall therefore shut up; I am afraid of letting
myself go, of compromising you. It is true that you

are like those women so high up that nothing compromises them.

People are going to talk about fantasy, about dancing. The refrain will grow louder owing to the great things I am nearing. I shall have the scene made to me where Michol says to David: "Dancing before the ark—you! at your age! on the sidewalks!" I can guess his answer: "Madam, I have danced that dance I used to dance while I was a little Idumean shepherd; I was milking the goats, and this pretty dance was taught me in exchange for my milk by the caravans returning from Memphis."

It will certainly not be you who will make this scene to me. You know that I avoid philosophical language on purpose, that I merely try to be clear in a region where clarity cannot penetrate. I want my ideas to be touched, I want people to be able to lay them out on a table. It is the opposite of the *style de luxe*.

It would be easy for me to magnify my text, if need be, to raise it onto a pedestal. But then, all the connections and pipes! How badly my pollen would fly!

Our times are infested by boobs with horn-

rimmed glasses who hang about the theater wings of audacity, talk loudly, and judge everything. Already I hear them saying: "What's the good of this letter?"

Make way for the marvelous, young rogues! This is a love letter. *Le Coq et l'Arlequin* was a love book. It was born of the weariness of my ears just as this letter is born of the weariness of my soul. It could be a success or not be one. Making the music it speaks of depended on the musicians; they made it (13). Stripping the foolishness from the heart is a concern of poets. To sustain them is your role, my dear Jacques. I myself have only the strength to cry: "No more bets."

J.
Villefranche, October 1925

P.S.

(1)

I am considered witty. The thing is to decide on the meaning of the word. Nothing irritates me as much as a piece of wit. If I let one escape I am ashamed of it as of a wind. For me the perfect

example of wit is the Devil dictating to Pascal the invention of the roulette. Madame Périer relates: *"Absolutely kept from sleep by a toothache, during these long watches there came to him one night, without purpose, some thought on the idea of the roulette; this thought was followed by another, and that again by another, finally a multitude of thoughts coming one after the other, uncovering for him, as if in spite of himself, the demonstration of all those things at which he himself was surprised, etc. . . ."*

Here can be recognized the Devil's accelerated rhythm. Making Pascal one's accomplice, here's something that is exciting, that is *tremendous,* to use the vocabulary of people of wit.

I know only one man in whom wit is Spirit [1]— Father Mugnier. The little body that modestly clothes this great soul possesses the divine power of being everywhere at once. Every day he helps poor and rich at every corner of the town. One of the parlor games consists in placing him in danger, in leading him onto an off-color subject. You should hear how Heaven whispers to him an answer that beats and checkmates the worldly player.

[1] ". . . chez qui l'esprit soit Esprit." *Tr.*

(2)

Radiguet, soaked with drink, on the day he arrived in the country, would go on a water and milk diet without effort. It is to this alternating regimen that we owe his books.[2]

(3)

Here is an instance of how Radiguet functioned: he could not see a yard off. Feeling that wearing glasses would make him seem to be following the American fashion, he took to the monocle. This monocle gave him an arrogant grimace, made him ridiculous. He noticed it, and kept on with it. For him a monocle was a piece of magnifying glass which would uncover for him simpletons, in whose eyes a monocle represents the Boulevard.

(4)

When Gide wrote me after *Antigone,* "Patina is the reward of masterpieces," I answered that it was rather "the makeup of daubs."

[2] Baudelaire, in his preface to Edgar Poe's works, speaks of *"those men . . . quickly going to excesses and capable of astonishing sobriety."*

(5)

If someone who is disintoxicated thinks he can smoke a pipe here and there, he allows the black ivy to take hold, climb and flourish anew within him without his knowledge. Nothing can describe the ruses and the movements of opium to get revenge upon a person treating it with disrespect.

(6)

A common man smoking is endurable: he is ennobled, as are the boulevards photographed in slow motion.

(7)

The Church enticing people—that's a good one! I like that Villefranche sexton who chases me out of the church at six because it is closing time. He rattles his keys, he calls to me from one end of the nave to the other, he bawls me out because I do not go fast enough. Let us not forget that Max Jacob searched for six years for a priest who would hear him. It is admirable to see the Church so sure of herself, so deeply and dialectically constructed, and so little anxious to attract souls or to hold them.

(8)

I guessed well. Everyone saw the trap. Massis
writes me : "And I was aware, when Father Charles
burst forth into our midst on that unforgettable
evening, of the divine presence that was going to
shatter your heart from within, throw it topsy-
turvy with love . . . draw you out of that climate
of death where you were destroying yourself."

(9)

In my school I shall teach :

Not to mistake seriousness for death. To take
Satie's formula : what is serious cannot look serious ;
amuse yourselves. But here I use the verb "to
amuse" as Racine used the verb "to bore." For
me to amuse myself it is not enough that I walk
about the game room, and risk my pocket money.
I must throw myself body and soul upon a color.

I shall teach that there are hardnesses and hard-
nesses. The Blessed Virgin is hard. *Le Bal du Comte
d'Orgel* is hard. Jazz music is not. A puppet is not
a diamond.

I shall teach that the need of change in art is

nothing other than the need of finding a fresh place on the pillow. Put your hand on the fresh spot, it soon ceases to be so; newness is freshness. The need for novelty is the need for freshness. God is the only freshness that does not grow warm.

I shall teach how to *fabricate* poems (the term is La Fontaine's) and, for the rest, I will let God take care of it.

I shall teach that art is religious, and I shall reveal the danger of religious art.

I shall communicate the strength of little things and the disgust for pomp—which is a mirage of the devils to make us lose contact, through the centuries, with the human weakness of Jesus and the detail of His fortunes. For just as we remember a childhood pond and shrub as a lake and a tree, in the same manner, seen from a distance, we magnify the low cross and the mound of Golgotha —an illusion that excites the mind at the expense of the truth which touches the heart. I shall pass on the taste for exactitude that is poetry, the sense of volume and matter to which the public remains insensible, flattered as it is only by silhouettes and wild daubings.

I shall teach the importance of changing opin-

ions without fear of self-contradiction. So many periods, so many points of view.

I shall counsel students always to act in a way that their deeds be approved by God, even if they remain incomprehensible, that is to say, criminal, at the tribunal of men. As one might say, the recto of perversity.

(10)

One must remember the Loeb-Leopold case. Richard Loeb (19 years), nicknamed Angel Face by his friends, and Nathan Leopold (18 years), belonging to the rich Jewish Chicago society and the pride of the University, murdered gratuitously, as Gide would say, a boy, Bobby Franks, the son of Jacob Franks, a friend of their families, after painstaking preparations to keep from being discovered. Leopold's horn-rimmed glasses falling near the corpse were the error in construction that wrecked the masterpiece. Their attitude during the trial was faultless. They laughed and contradicted themselves on purpose to upset the judges. Angel Face and his weak, admiring accomplice, accustomed to luxury, accepted hard labor without disgust.

The truth, the true truth, more true than the secret truth of the case, is that Clarence Darrow should have replaced his counsel's speech by a course in literature, and the weapon Loeb put into Leopold's hand should have been a paper cutter.

An indispensable detail: Leopold charmed birds. He assisted science. Wild birds would alight on him and let pictures be taken.

(11)

Scandal and solitude, a kind of sensational flop, that is something hard. It is the only thing that suits me. Jesus sets the example for us. Can you imagine him becoming a rich patriarch? He always shocks, He discourages luck, He exposes Himself, He makes Himself ridiculous, He makes doors close on Him, He crucifies Himself.

(12 A)

Stravinsky played his *Serenade* for me. What is striking is the dialecticism of the work. A notary explains very complicated money matters. In that suite it's impossible to bask from place to place. To lose a stitch is to lose the thread, it means listening out of sheer politeness.

Effectiveness of Repentance

Stravinsky was reading in a newspaper the following story: "In England, at an atheistic gathering, an orator was going beyond the limit of blasphemy in the midst of general uneasiness. Suddenly he insults the Virgin. He turns pale and falls, thunderstruck. "That man," Stravinsky adds, "must have gone straight to Heaven, *for he died of shame."*

(12 B)

Acting and venerating are two different things. To my deep regret, I had in 1916 to seem as if I were attacking Debussy. In reality I was attacking Debussyism. You have guessed the game of the impressionistic musicians. They went about it with such skill that Debussy suffered much from it in the year of his death. The present friendship of Louis Laloy for our group and for myself proves how much my attitude changes when pure eyes take the trouble to look into it closely, with attention.

Besides, I must denounce in Laloy one of those religious minds, against all appearances, one of

those thinking minds, beloved of Heaven. One can have surprises. In 1916 Satie was our school master. From the year 1923 we heard Stravinsky speaking our language better than we. The lack of appreciation he enjoyed in this new period proves to what point our language is disdained.

THE CRITICS: "Mr. Stravinsky discovers the classics."

STRAVINSKY: "That is exact. I knew them; I knew them as you did; I had not discovered [1] them."

[1] Pun. Cocteau means both "discovered" and "uncovered" (or "unveiled"). *Tr.*

Answer to Jean Cocteau

ANSWER TO JEAN COCTEAU

My dear Jean,

I know myself too well to see in the features you lend me anything other than the image of your heart. Friendship is your excuse.

What am I? A convert. A man God has turned inside out like a glove. All the seams are on the outside, the skin is inside, and is of no more use. Such an animal has trouble feeling itself to be something; it would like to ask pardon of the others for being in existence. Their fur coats, their horny shells impress it. I know you understand this, although in your case it was not a question of abandoning heresy for the Faith, but merely of taking back your pew in church. Your guardian angel kept the place, writing your name every morning on the prie-Dieu.

You have always cared about angels. You speak of them in all your books; their name made streaks of blue on all kinds of objects you touched. You would see them in window pane reflections, in the sensitive mirror of analogy, in enigmas, diagrams and rebuses; in poetry you were gradually redis-

covering them, you were sensing their immensity, their strength, their tenderness, their elegance, their danger. For, to tell the truth, it was they who were catching you in a trap, holding the bird-catcher in their nets.

My own philosophy was deeply concerned with them. It had entered into the treatise of the Angels, conducted by the Angelic Doctor and by John of Saint-Thomas (again another Jean, and whom I hold dear), and the world of separate intelligences revealed to it intelligible lights more beautiful than the day. Such a philosophy had understood that only the pattern of pure spirits allows metaphysics to seize the essential mystery of the intellectual life; it never tired of admiring the angelic natures—where each individual is a species by itself—who see all creatures in the light of the creative ideas; who choose and who love once for ever, in a not-to-be-uprooted act their whole substance is engaged in. That was the logic of our having come together. The angels that guard us had been watching each other for a long time; they drew up their plans from afar. Jean, they see the face of the Father. Their morning knowledge exults in grace and in glory in the vision of the Word, where all

is resplendent; their evening knowledge submits to itself the whole world-machinery by virtue of created causes, and by right of nature. They saw Lucifer fall, they adored at Golgotha, they were present at the coronation of the Virgin. Can you imagine their prayer? In their eyes we are two little shadowy points moving about in the flame, but whom Jesus has loved. Two children—you said it truly, my dear Cocteau.

I knew you before you knew my name. I followed your poet's moultings with diligent curiosity; I looked upon you as a kind of jinnee who occupied himself with catching the pure and impure games of fairies by surprise, who moreover was sated with sadness, and made for another world. Your enormous consumption of diver's suits struck me greatly. With *Le Cap de Bonne Espérance,* the diver's suit became an airplane; in that I saw an expanding of the mystery, whose rashness was my delight. I admired *Les Mariés de la Tour Eiffel*—I saw in it, freed for the theater, the untrammelled imagination that long ago thought up the eternal tales.

When Auric read us *Le Cap* we were living, thanks to the most hospitable of parish priests, in an old country vicarage, furnished by a miracle,

where I was working on the theory of the universal
in praedicando, by the bedside of my sick wife,
who suffered there more than a year without letup,
and who every night dreamt of a deluge of flowers.
It was in this green land that *Art and Scholasticism*
was composed by her and myself. Hardly was the
manuscript finished than there arrived unex-
pectedly (as always happens) the one who, a few
years later, was to become Father Charles. He
brought me in his pocket, purchased in Paris "by
accident," *Le Coq et l'Arlequin.*

Your tightrope esthetics met without difficulty
the scholastic theory of art. With a sagacity which
enchanted me, you were formulating for poetry
(concealed beneath the music) the great laws of
self-purification and self-denudement that rule over
any spirituality, the law of the work to be done as
well as that of the eternal life to be attained, and
whose supreme analogous pattern (though trans-
cendent and supernatural) is to be found in ascetic
progress and contemplation. You wanted of poetry
only poetry in the pure state, the pure demon of
agile grace, the pure agility of the spirit. And you
were faithful to your vow; you left what you had,
you risked everything at every moment, constantly

unbinding yourself from yourself, reducing the matter and weight of body to such a point that people reproached you with having no more substance. Not for a joke did the Greco-Roman charms of the rather plump Muse give place for you to the hardness of a Spirit come from the Orient of the sky. At that level you found yourself lifted, as if by trickery, to a struggle waged far above that of art and poetry, there where without the helmet and armor of Christ one is lost before beginning, you grappled with forces immune from matter, death closed in on you from all sides, it silently immobilized the reckless ones who loved you. There was no need to be a great wizard to have guessed the existence of that struggle against death that now you admit, now that death has lost. I was aware of the tragic in your practices and in your life; trapeze-swinging, acrobatic stunts, false bombs, false scandals—back of the circus gleamed the fangs of real beasts; you juggled so high and so squarely with your knives that an accident was not avoidable: one would see you with your heart opened by despair, or by the grace of God.

We offered to each other complimentary copies of our books, with a look of detachment. Radiguet

sent me *Le Diable au Corps*. You it was who was to sign my copy of *Le Bal*.[1]

Delirious with fever Radiguet said to you: "In three days I will be shot by the soldiers of God." He died on the third day.

It was a few months later that Auric took you to see "the people" he knew at Meudon. Yes, death was squeezing your neck, Mercutio! But I realized that indeed your life was tenacious. I realized also how true it is that your greatest stratagem is sincerity; I admired the fact that you were informed with such clarity on recipes that are difficult to use even when one does not know them.

Then we wrote each other. From Villefranche, in August 1924, you said to me: "The first one from our groups, I wanted to see something white again. I first tried the thing out on the musical world. You know some results that are of consequence. With *Thomas* I did something white, but by means of utensils grimy with nicotine. From among all the others I chose Radiguet to become my masterpiece. Imagine that death, and I, alone,

[1] *Le Bal du Comte d'Orgel,* a book by Raymond Radiguet published after his death. *Tr.*

as if insane, in the midst of a crystal factory in smithereens. Here, I am trying to live, I am not very successful. Auric helps me. But what can he do? I inhabit a nightmare, another world where even friendship does not penetrate.

"Doubtless instead of letting myself drop I should reach up my hands toward heights. I am ashamed of having no longer the strength." And you spoke to me of Reverdy, of a Jesuit Father, and of their friendship for me . . .

When I saw you again, in December, you came to talk about God. You were frightening to me; before you I felt my native gaucheness increased by the impediment of my syllogisms. Was I a peasant from Heaven? From the Danube [1] also, and what's worse, from the Montagne Sainte-Geneviève.[2] But you did not hold my awkwardness against me, and you, too, you groped about amid shadows more real than our hands and eyes; our souls met in that Limbo.

God gave you no rest. You found yourself in that

[1] "Paysan du Danube"—a French popular expression meaning a simpleton who says everything he thinks, the way it first comes into his head. *Tr.*

[2] District of Paris containing many universities and libraries. *Tr.*

state where the inner self is shackled, which is like an agony of the mind, and with which Jesus is accustomed to being preceded. What could you do? Wait, and pray.

Only opium gave you an appearance of respite. A medicine prescribed like bloodletting or a mustard plaster, and used according to reason? If it were only this, no moralist would condemn it. But opium has more wondrous powers, and that is its crime. The fact is, opium helped you. ("Another new path!" Claudel said to you.) This is what we call a *per accidens*. These entities play a great part in human life. God puts everything to use, even evil.

Is that a reason to do evil? It would be too silly. Nevertheless it is a reason for strongly respecting the longsuffering of a Providence that goes far beyond our foresight; and for always hoping, since *all things co-operate for the good of those who love God, etiam peccata,* even sin. Reparation in grace is more able to unite than sin was to separate. . . . Yet for you, my dear Jean, at that time you did not yet love God altogether as you should, and sin seemed to you, I think, rather an infraction of some celestial customs-house rule than what it really is—

God's murder. A mischief which, reaching the Uncreated Himself—can that be imagined?—not in Himself, but in the essential order of things willed by Him, crucifies creative love.

Sin is a mystery, of which the saints themselves have but a very imperfect idea. So how could *we* try to explain it? There is nothing more incomprehensible. Only in the liturgical spasm of Holy Week—a lamentation of the Church convulsed—and in the horrible mirror of universal suffering can we guess something of its nature. Hell isn't much compared with it. God is too good, it is said, not to forgive. That is exactly what He does: everything, He forgives everything the moment the heart repents. If the devil repented he would immediately be forgiven.[1] But sin without repentance *cannot* be pardoned, any more than God can annihilate Himself; sin postulates a world of its own, deprived of God as it is itself, a fire of its own nearly as hard as that of charity—and where nevertheless God's pity, which is absent from nothing, makes it so that one suffers less than one deserved. Love created everything in order to diffuse the divine beauty; it

[1] This, by the way, is impossible: a pure spirit does not change.

cannot be vanquished. If I refuse to manifest it
in mercy I shall manifest it in justice. It is this
refusal that is obscure.

God permits evil without co-operating with it;
He does not wet in it the tips of His fingers. If man
permits himself evil for a greater good he soils his
hands, and his entire body. Shall I condemn the
opium-smoker because he is trying to free himself
from this lying life? No, but because he uses
wicked means, he makes use of an evil to flee evil;
he trusts a lie to escape lies.

Wanting to cure oneself of the human by the
means of man—or of animals, or of plants—is a
homicidal error. Such an error circulates in all
false mysticisms, and is materialized in opium,
where it takes a vegetable form: the poppy in place
of the Paraclete. Opium is most perverse when it
lends itself as a vehicle of a spiritual life, and claims
to lead to that Emptiness that God alone can pro-
duce. Quietism in pills, sacrament of the devil.

It is opium, you tell me, which left *you*. But you
needed courage. In your room at the sanatorium,
near your bed, there lay out in the open (as in the
Purloined Letter, the doctors never saw it) a little
box with a store of pills: enough for you to escape

at will from the suffering of disintoxication. You never touched it.

The treatment was a success. You were cured of opium. God kept on pressing you. Reverdy and I could feel the time coming when you had better see a priest. To whom would you turn? It was then you met Father Charles. If there was conspiracy, it was the angels. A telegram warned me of his arrival the very day that you were to dine at Meudon. When he entered we knew at once, by a great eddy of silence in our souls—and which lasted till the end—that he came only for you. This heart that you draw at the bottom of your letters, he was wearing over his chest, but with the cross planted in it. Solitude was sending you a contemplative; contemplatives and poets understand each other: a man accustomed to the ways of Heaven was at ease with your invisible. And then Charles' simplicity, his inner freedom, his self-effacement in love, that was the style you liked—in a work done by God.

The Lord is generous, His grace bursts like a hand-grenade, and with one burst makes many victims. He did not want you to return to His house alone. Two baptisms, soon doubled, a vocation to the priesthood, other graces still, followed your

meeting with Jesus. (Six months later it was be-
tween your two god-children that I saw you com-
mune on Christmas night.) Confident in my virtues
as brother gate-keeper you would send me those
souls whom your example enlightened. Thus we
exchanged friends, each giving them to the other,
without losing them for that. Yours were for me a
proof of the power of poetry, which worked on
them through you. Poetry had not made them wise,
but it had unlocked their hearts; it had put in
them the sense of what is pure. Without yet curing
nor even nourishing their souls, it had scoured
them on the side facing Heaven. They found them-
selves strangely available to grace and to super-
natural truth; I would see them drink with divine
avidity, *quasi modo geniti infantes,* the virginal
milk of the Church. Such souls, my dear Jean,
testify to the spiritual virtue sheltered by your
games.

During this time poor Satie was completing his
death. You refer to what he used to call, discreetly-
maliciously, his "kind of conversion." Ah, do not
lay anything to my account here—I was his friend
and nothing more. The first time I came into his
room, at Saint Joseph's hospital—Pierre de Mas-

sot, who had brought me there, had gone out for a moment—he said to me point-blank: "You know, I'm not so anti-God [1] as all that. When I am well again I'll turn over a new leaf, but not right away so as not to shock my friends. And anyway, I've always made my sign of the cross every morning . . ." That was how things happened.

Can I put aside such memories? On Holy Saturday, as the chaplain was going down the halls according to rule to know who wanted to make his Easter duty—"but of course," he answered, "I am a Catholic, I am." He confessed that evening, and as he had forgotten his prayers he asked the sister who took care of him to help him do penance. They recited together the Our Father and Hail Mary; Satie was weeping. Twice again he asked to commune. He confided to Reverdy his acts of piety in that inimitable tone, half-grave, half-mocking, which his *pudeur* gave him when it was a question of himself.

With me he talked mainly about music and cooking, about the astonishing dishes Brancusi used to prepare for him. Once I was roundly scolded because I could not find a jar of jam that nobody

[1] "Antibondieusard." *Tr.*

knew what dark manoeuverings had made dis-
appear. I was digging into all the drawers. "There's
no use being a Catholic writer and not to be able
to find a jar of jam. Just by watching you look one
can easily see you will never find it," etc. On the
whole, during this horribly long and cruel illness,
he showed an exemplary patience; and always that
curious sense of order—reasonable, ironical, metic-
ulous, and preposterous—which with him had such
a deep significance. At the end he would take to
dozing off, waking up for short moments. As I sat
beside his bed, reciting my rosary in a low voice,
he woke up and said to me: "It is good to be
together, when one thinks alike." Then he fell
asleep again. Those were the last words I heard
from his mouth. At the end of half an hour I left
on tiptoe. I did not see him again until he lay in
the coffin. He had received extreme-unction in full
consciousness. I believe his prayers do much for his
friends.

Art has trouble defending itself against an im-
pure angel that slaps it in the face, that wants to
make use of everything for self-love, of the very
gift the heart makes of itself, of its weakness even;
even of God. We know this very well, my dear

Jean, we see this game everywhere, to which the religious awakening in the world of *letters* will give a new sheen, and a new food; for the thin and the thick strokes [1] take advantage of everything.

But we also know that many publicans and prostitutes will precede in the Kingdom of Heaven many just ones who are pleased with themselves. That is the testimony of the Lord. He found there more innocence of heart than in the casuists of the Temple.

What stops short uncreated love is pride of spirit. However showy it may be, the artist's vanity usually remains childish, and does not reach to that height of sin. He is not sure of his salvation, he knows he pays badly the tithe of mint, anethum and cumin, and that he is no better than the rest of men: clearance is given to mercy.

In the artist there is a *littérateur*: a double heart, a mummer that would fool God.

There is also a craftsman, sometimes a poet: an apprentice of the Creator.

[1] ". . . les plains et les déliés"—refers to the strokes used in handwriting; the preceding word *"letters"* thus means both literature and alphabetical letters. *Tr.*

God does not allow Himself to be fooled; he hates literature. He loved the blue eye of Satie.

Satie's mystifications have been spoken of to repletion. In the universe of music they were of the same quality as those of a Saint Philip Neri in the universe of grace. Here is the crucial point: art is with grace in the habit of symbolizing. Between the world of poetry and that of sainthood there exists an *analogical* relation—I use this word with all the force metaphysicians give it, with all that it implies for them of kinship and of distance. All errors come from the fact that people misread this analogy: some swell the similarity, mixing poetry and mysticism; others weaken it, making poetry out to be a craft, a mechanical art.

Yet poetry is from on high—not like grace, which is essentially supernatural, and which makes us participants in what belongs to God only, but like the highest natural [1] resemblance to God's

[1] I say "natural" in opposition to the essential supernaturalness of Christ's grace. This does not alter the fact that in another sense, just as first philosophy is called metaphysical, poetry can be said to be super-natural, insofar as it transcends not the whole order of created and creatable nature, but of sense-perceivable nature and of all the laws of the material universe, and as its values are of a transcendental order.

activity. *Our art,* Dante used to say, *is the grand-child of God.* And not only does it derive, as from its pure archetype, from that art that made the world, but in order to have some idea of its no- bility one must call to mind the mystery of the procession of the Word: for intelligence as such is prolific, and there where it cannot produce an- other itself as in God, it wants at least to beget a work, made in our image and where our heart would survive (1) .[1]

There is an inspiration of the supernatural order which moves us through the gifts of the Holy Spirit, and which presumes charity; it raises souls of saints to the superhuman mode of acting which makes up the mystical life. But in the natural order also there is special inspiration which, too, is above the deliberations of reason, and which proceeds, as Aristotle observed (2), from God present in us. Such is the inspiration of the poet. That is why he is indeed a man divine. Like the saint? No. Like the hero: *divus Hector.*

Words, rhythms are for him no more than a medium-matter. With them he creates an object that gives joy to the spirit, where shines some re-

[1] Numbers in parentheses refer to the notes at the end.

flection of the great star-filled night of being(3).
Thus he sees into things and brings forth a sign,
however minute it may be, of the spirituality they
contain; his blind man's glance meets, at the bosom
of the created, the glance of God. The Holy Books,
say the theologians, have several literal meanings;
in the same way, there are an infinity of literal
meanings in the things made by God. Just as the
saint completes in himself the work of the Passion,
even so the poet completes the work of creation;
he co-operates in divine balancings, he moves mys-
teries about; he is in natural sympathy with the
secret powers that play about in the universe.

Poetry, in its pure spiritual essence, transcends
all technique, transcends art itself; one can be a
poet and still produce nothing, just as a child bap-
tized has sanctifying grace without yet acting mor-
ally. Metaphysical ratio: poetry is to art what grace
is to moral life.

Nay, Poetry is an image of divine grace. And
because it brings to light the allusions scattered
throughout nature, and because nature is an allu-
sion to the Kingdom of God, poetry gives us, with-
out knowing it, a foreshadowing, an obscure desire
for the supernatural life. I remember how Baude-

laire put it: "It is at once by poetry and *through poetry,* by and through music, that the soul catches a glimpse of the splendors lying beyond the grave." And he added: "When an exquisite poem brings tears to the eyes, these tears are not the proof of an excessive joy, they are rather the testimony of an irritated melancholy, of an insistence of the nerves, of a nature exiled in imperfection that would like immediately to take possession, on this very earth, of a paradise revealed."

You know these secrets more clearly than I. Who has realized better than you all that is reflected of evangelical wisdom in poetry's self-conceited soul? Poetry, too, imposes the narrow road, it presumes a certain sacred weakness—beauty limps, you say, and Jacob limped after his struggle with the angel, and the contemplative limps in one foot, says Saint Thomas, for having known God's sweetness he remains weak on the side that leans on the world. In one sense poetry is not of this world, it is in its way a sign of a contradiction: its kingdom also is in our midst, within us. It is, too, a bit of nothing, a very small thing, a morning light which will grow to the fullness of day; it demands in its own line a genuine spirit of poverty. It abandons every-

thing for its absolute. It wins its freedom through constraint. It means to have the poet unresistant, heroically docile, but to have his self-abandonment accompanied by intelligence and will, thus making it comparable not to the automatism of madmen nor to the fury of the possessed, but to the vigilant and free passivity of souls acted upon by the Spirit of God.

All this, however, at the service of a good that is not the Good. From all the masterpieces in the world one could not draw forth a single movement of charity. We would give, Jean, all the poems and all the systems for the hidden repose in love [1]—invisible even to the natural glance of the angels—of a heart united to God.

The point is that art stands in a line that is not the line of man's good(4). From this comes its strength: it is free of the human, it is not constrained like prudence to regulate with regard to an end fixed in advance, in the mess of the contingent, the indetermination of free will; art has for its end only the object it has chosen; it despotically dominates its matter. But from this too comes its infirmity. If there exists for the artist a whole

[1] ". . . le petit repos d'amour" *Tr.*

organism of spiritual virtues, they are virtues in a certain sense only, yet they are real(5) ; they imitate, without achieving them, true spirituality, and the virtues of the saint. This is a tragic condition indeed. The artist knows the hardness of the life of the spirit, but he does not taste its hidden peace, which nothing created can give. His will and all his strength of desire he must discipline without mercy, but for an end that is not his end.

In itself, independently of the motives that set man to his work, the artist's purity, however dear it may cost him, helps him in no way to save his soul. But it is nevertheless a genuine purity, paid for by weight of the sufferings of a created mind, and which is an emblem of the truer purity; and which, in emblematizing it, prepares it. A slide down the inclined plane of Heaven, a push from grace: the sleeper will change sides, and will wake up with God. God knows the work of men, the reverse side of their effort; everywhere He sets His traps, His actual graces; God sees the tiniest corner of innocence in the heart. There is the pity of God.

Understand me well. As I do with metaphysics I abase poetry only before God. Poetry is not abased

by being abased before God. I point out its great-
ness; no one comes so near the invisible world as
the sage and the poet, unless it be the saint—who
is but one spirit with God, and so infinitely closer
to Him than anyone. I also point out the blessing
men receive from poetry.[1] Though in themselves
of no help to the attainment of eternal life, art
and poetry are more necessary than bread to the
human race. They fit it for the life of the spirit.

Saint Francis talking to the animals—when
grace restores something to the state of innocence
it restores it in actual fact. Art restores paradise
in figure: not in life, not in man, but in the work
produced. *There all is but order and beauty*[2];
there, no more discord, spirit and senses are recon-
ciled, sensual delight pours out in light, bodily heat
in intelligence, the whole human reality conspires
toward Heaven.

Even with regard to sin art still imitates grace.
He who does not know the regions of evil does not

[1] "Nobody," says Saint Thomas, "can live without pleas-
urable feeling. That is why he who is deprived of spiritual
pleasures passes to the carnal ones."

[2] Paraphrase of a line from Baudelaire. *Tr.*

understand much about the world. If the stoic is unaware of them (he does not believe in the devil), the saint knows them well. He is taught by temptation—in comparison with which the paltry practices in sin of so many good young men who are afraid *not to live* are poor scale-practices indeed; with his master, the saint descends into hell(6). Familiarity of old foes: a stranger to evil he knows nevertheless its whole nature and all its recesses. Why? He redeems it by his prayer and his pain. He takes sins upon himself. By means of the Savior's alchemy he transmutes them into charity.

Well, the artist, too, knows the recesses of the heart(7), he visits low places. I do not presume to say like André Gide that they are the most fertile ones(8), for in the things of the spirit it is virginity that is fecund; yet they have their own kind of low fertility.

Just as it is part of the universe of Christianity, where it constitutes the exclusive matter of one of the sacraments, sin is a part of the universe of art. But it is for a false redemption. With it art makes a work, it draws beauty from it: but it is beauty from dead matter.

Art—an illusionist—transfigures evil, it does not

cure it. The prodigious sensuality of your enemy Wagner is so sublimated by the operation of his music that *Tristan* calls forth no more than an image of the pure essence of love. The fact remains that if Wagner and Matilda Wesendonck had not sinned together, we would not have had *Tristan*. The world would doubtless be none the worse for it—Bayreuth is not the Heavenly Jerusalem. Yet thus does art parody the *felix culpa*. It behaves like a god; it thinks only of its glory. The painter may damn himself, painting doesn't care a straw, if the fire where he burns bakes a beautiful stained-glass window.

Moreover, should art come to mix with life, it induces man to seek his perfection, like that of a masterpiece, in the sheer flowering of his nature. This is pure self-deception, to tell the truth. For man has lost the power of attaining his natural perfection; it is a supernatural perfection that is offered him; and "on the road to natural perfection he meets with sin." He is an inevitably scarred creature: either he bears the wounds of the old Adam, or those of the Crucified One.

To sum up, art is un-human, as sainthood is super-human. From thence come all the analogies

I have spoken of, and this insistent demand for heroism; but also this voracity of an idol, and this lie, and the temptation, which seems to trail it through the ages, to ask from perversity an impossible equivalent of the supernatural.

That, however, is the pretty monster you want to appoint as deputy to the Lord. "Art for art's sake, art for the people are equally absurd. I propose ART FOR GOD." A motto that is paradoxical yet not chimerical, since the Middle Ages (in their own way, which can no longer be ours) were spontaneously faithful to it: the world, it is true, was then exorcised; the four elements were Christian.

Religion and poetry have their quarrels, yet these are quarrels among sisters. The artist has great trouble in making use, without hurting himself, of a creative virtue that is too hard for him as a man. But art itself goes spontaneously to God. To God not as man's end, not in the moral line. To God as the universal principle of all form and all clarity. From the moment it reaches in its own line a certain level of greatness and purity, art heralds without understanding them the invisible order and glory of which all beauty is but a sign;

Chinese or Egyptian, it is already Christian, in hope and in symbol. And certainly *to paint the things of Christ one must live in Christ,* as Fra Angelico said. But one must first be a painter. An art which does not paint the things of Christ because it considers itself still unworthy of that, or for any other reason, but which snatches real pieces from Heaven and renders "the inimitable sound of the impact of intelligence upon beauty," is the art that from a greater or lesser distance prepares for grace (for the time when grace will want to make use of it) the most worthy instrument. I am thinking of Satie's *Socrate,* Stravinsky's *Noces,* the figures of Rouault and Picasso, and your *Orphée,* my dear Jean.

Church art, which makes objects before which one prays, owes it to itself to be religious, theological. Beyond this particular (and lofty) case it is quite true that God does not ask for "religious art" or "Catholic art." The art He wants for Himself is art. With all its teeth.

You are right, God demands early fruits. One offers Him as firstfruits the young of doves, the ram in all his strength. "He likes the antique, and not the old." Of course academic conventionalism

is not a way to please Him. He has a right over boldness; pusillanimity is everywhere the opposite of humility. "He will not stand," you tell me, "for any lukewarmness." That is true. Undoubtedly there will be in Heaven many people who were silly here below; it would be a mistake to think that consequently we must serve Him in a silly way. If sins against intelligence, against art, science or poetry are not paid for in the other world, they in any case are paid for on earth. The children of light, whom the Lord reproaches for coping so badly with things, have had a few chances to find this out.

"Remain free," Father Charles said to you. To many it should have been said: "Become free." And to others: "Become slaves again," according to Degas' advice. In your case, enough tenacity, enough suffering had already made you win your poet's freedom. I expect everything from this freedom.

You belong to Jesus; no sham order has any rights over you. Who is asking you to change ledgers? You belong to the Church, to the Mystical Body of Jesus, not to any world whatever it be, not even a pious one. The Church is a mystery.

The Church is Christ, Christ spread about and communicated(9). All she forbids us is sin. And since, there where love is, only sin imposes bondage, there is no way of being freer than in her.

You tell me that after last June's events I glanced at you surreptitiously. What was I seeing? A soul enlightened by the Lamb, painful still and resolute, bravely confronting Heaven, and putting its loyalty into not believing too easily in happiness. In the grip of Love, clinging to it and struggling against it. You are one of those who always give more than they like to promise. I was aware, Jean, of your generosity. But I wanted to see you profit better than myself from the graces of Jesus when He rises in the soul, that are tenuous, imperceptible, and that one fancies one is able to find again at will. May you run faster than I ran! My blue dove [1] flew like a desire, a prayer.

You have an admirably jealous longing for freedom. How well I understand your love for Antigone! Yet she herself tells us, and that is why she is dear to you, that in breaking human law she was following a better commandment—the unwritten and unchangeable laws.

[1] Cf. Note 1, page 19, of Cocteau's Letter. *Tr.*

The freedom of a virgin obeying the laws of the gods is more beautiful than that of the poet or philosopher. It is to a higher one still that we are called—to the freedom of the souls of whom the Spirit has taken possession. *But if you are led by the spirit, you are not under the law.*[1]

And have no fear, my dear Jean, scandal could not be absent. Whatever comes from God has always shocked people. Yes, let us observe the manner of Jesus: "Passing in their midst, He went." The world was saved by a *scandal through love* which the Synagogue has not yet got over, and the noise of which will never pass.

What most shocks our contemporaries is order, I mean order in spirit and in truth, which is as much the enemy—this is one of our axioms, yours and mine—of a stuffed order as of disorder. In philosophy it was a scandal simply to return, *because it is true,* to the wisdom of Saint Thomas. It is enough for wisdom to be wisdom for it to amaze, it is enough for poetry to be poetry. It is also true that the poet always finds it hard not to live on the food offered to idols, and not to deserve on this point the reproofs of Saint Paul.

[1] Gal. 5, 18. *Tr.*

The Lord sends to the depths of the sea, with a millstone around their necks, those who offend little children. In your case, it is those who have lost their childhood, "scholars and persons in such matters conversant," as Jeanne d'Arc's judges named themselves, whom you feel it is a good thing not to seek to shock, but to shock without trying.

In which you are not wrong. That is still not much in the world of art; it is in a higher order that it becomes serious. *All those,* writes Saint Paul, *all those who want lovingly to live in Christ Jesus shall suffer persecution.* That is the enviable offense—of which we are not worthy, alas!

In the XVIth century the Church shocked heretics; they felt she liked beauty to excess. As for me I admire the Renaissance Popes for having called in the whole beautiful universe to the help of the century-old mother of virtues, at a time when the Devil, painted up as a moralist, was letting loose his hounds on her. Not for having given too much to art and to visible forms must the times of Leo X be blamed, but rather for not having given enough to grace. *Haec oportebat facere, et illa non omit-*

tere. This it was needed to do, and that not to leave out.

In the XIXth century the opposite spectacle was seen: art and religion seemed to drift apart. Why? It is not hard to see. In religious circles taken as a whole (I am not speaking of saints) the level of religion was sinking;[1] the high regions of the spirit neglected, the theological life tended in many to give place to a life that was merely moral. Now without the higher light of wisdom, prudence looks upon art as an enemy. Even in a certain world otherwise reliable, the hatred of poetry seems to be a revenge upon the evil lusts that morality keeps down.

In artistic circles taken as a whole (I am not speaking of some great names), the level of reason was sinking in its turn. As he was undergoing the after-effects of a long unfaithfulness of the intelligence, one could see the artist seeking in the denial of spiritual values the human substance that is his food, and, while taking his own self for the ultimate, boiling down little by little all his vital-

[1] Religion had to rise up from the ruins caused by the Revolution; it was inevitably undergoing the after-effects of the harm it had suffered then. At the same time the whole mass of false philosophy was weighing against it.

ity into a delight of the senses. Today the misery
of the heart is so great that total despair is really
the only outlet of the poet who will not flee to God.

This double and simultaneous descent could not
but produce an increasing separation.

Art reflects customs and gives back to them a
hundredfold what it has received. It exalts the
corruption of corrupt ages. But the time comes
when by dint of isolation from the highest life of
man, art itself dies of starvation. Then it begins
groping about for Heaven. It may take the wrong
road, go astray in a false night that is but a coun-
terfeit of the divine night: we recognize the hunger
that is in it. Let it flounder, shout, blaspheme all
it will, it will be cured only if it finds Christ.

To tend toward the perfection of charity, to
operate according to beauty—these are two "for-
malities," as we say, which considered in them-
selves should easily be in agreement. Yet in man
nothing is easy. It is not easy to be a poet, it is not
easy to be a Christian, it is doubly difficult to be
both at once. For poetry excuses nothing. It merely
creates greater duties. And the difficulty has be-
come enormous at a time when the subtlest point
of art torments the most distracted sensibility. You,

my dear Jean, know the secret of perilous suc-
cesses—you shall teach it to our friends. Your
program is good.[1] At the same time, do not let
them get a false idea: they are invited to a tough
game, where there will be wounded and dead.
Although I strongly desire such a game to start I
shall push no one into it. But to the "fellows capa-
ble of everything" who want to try their luck, I say:
You will be able to take it only by grace. The order
of active causes corresponds to the order of ends,
ART FOR GOD supposes GOD IN ONE'S SOUL. With
the Eucharist you will become capable of the im-
possible, you can touch poetry without dying from
it.

Yet let them remember that the Gospel is hard.
From the very start it lays down imperative con-
ditions. It says: Let the dead bury their dead. If
you do not hate your soul because of Me, you are
not worthy of Me. God is not mocked. These words
shall not pass.

For a man who has not chosen the good once
and for all, it is not enough, Jeremiah said, to cry:
The temple of God, the temple of God, the temple

[1] I point out in particular the invaluable note 9 of your
Letter.

of God. Religion can, like nature, furnish art with objects, yet it is not a literary object itself. It can *animate* art as the mind animates the body, without mingling with it; in mingling their two essences one soils them both. We agree on that.

Will we have to witness, we who—without liking neo-classicism—do not confuse romanticism with prayer, a kind of Catholic *Sturm und Drang*? After the madness of the Cross any other madness is timid indeed. And that madness does not like noise.

I am hoping for something else; like you I am expecting a new poetry, freed from Rimbaud while remaining aware of what it owes to Rimbaud, a poetry of Easter morning, free like the glorious bodies. In what manner will you be followed down the road you are advancing with Max Jacob, from which death removed Apollinaire and Radiguet? It is not for me to say—I am only a philosopher. Yet I see a sure promise in the moving effort, pursued for ten or fifteen years, to throw away all the dead weight of carnal denseness, ostentation, complacency, false understanding, adulterated perfection, that literary expression carries along. Disabled means, stutterings, deliriums, do I hear said? It is

still poetry struggling against lies—against original sin, in the final count. If their road seems to me to be without outlet, I do not any more than you misprize the friends of Lautréamont. But I also know that it is vain to force poetry to ape the mystic state, and to seek the heroic life in the word of man. Dreaming is but a false deliverance. It can help to renew the language's resources, the deeper life of verbal imagination, it can help to purify words of the soiling of common usage; it will furnish after all only a technique. There is no spirituality without the spirit. Outside of God and His shadow there are only fake mysteries. "Literature is impossible. We must get out of it. No use trying to get out through literature; only love and Faith allow us to get out of ourselves." This is truth itself. Thank you for having said it.

No, my dear Cocteau, I shall not make you the scene of Michol and David. Nor am I frightened at your aiming so high. Always aim at the head, Léon Bloy said, to be sure never to hit lower than the heart. I think as you do that where extremes touch is a choice place for intelligence. Right at the joining of the arms of the cross. It is the only place from which one can see well. And finally

I am with you on this, to say and say again that, in any case, nothing good will ever be done without love.

Honest love is the supreme rule of the poet who loves his work, of the saint who loves his God. *Love,* Saint Augustine used to say, *and do what thou wilt.* To freedom—which makes up the one and only problem—only love gives the key. Where charity and love are, there God is.

But love itself presupposes knowledge. If it does not pass through the lake of the Word it proceeds not in spirit but in violence. Without intelligence it can do nothing. There where faith is absent, charity is absent.

On a corrupted reason all that is built collapses. That is why I have given my life to Saint Thomas, and labor to spread his doctrine. For I too want intelligence to be taken from the Devil and returned to God. I am not asking that everyone be a philosopher and a theologian—that would be the death of these lovely sciences. Everyone must know according to his measure. I say that if you do not have an honest mind, and if you have contempt for wisdom, all the goodness you want will turn

to evil. It is possible for all to listen to the wisdom
of the Church: because of this, intuition can with
many replace science without too much danger;
and love cover itself with eyes.

This eye-covered love of intelligence, that is what
you call the heart, isn't it? *The illuminated eyes of
the heart,* say the Scriptures. The heart that marks
in red the whiteness of desert hermits' robes is the
Heart of Truth.

Much love is lost in the world outside of truth.
The Church, where love and truth are together,
widens her mystical boundaries to get this love
back again(10). She has just instituted the Feast
of Jesus' universal kingship. December 31, 1925:
the Pope celebrates this feast today for the first
time, he proclaims that all the human race belongs
to Christ. He consecrates it to His Heart. He prays
for all men. "Lord," he says, "be thou the King
not only of the faithful who never departed from
you, but also of the prodigal ones who abandoned
you. . . . Be thou the King of all those who have
gone astray into the darkness of idolatry and Islam-
ism, and do not refuse to draw them all to the Light
of Thy Kingdom. Finally, look with mercy upon
the children of that people that was once your

favorite: allow to descend on them, but today in a baptism of life and redemption, the Blood that once they called down upon their heads." [1]

You mention the Jews. How better can you be answered than by this Catholic prayer? I by no means hold as negligible the problems of political order created by the diaspora. They are weighty, chiefly for the shoulders of the Jews. I do not think that before her reinstatement in Christ Israel will cease being torn between the requirements of her divine calling and those of her identity as a people, that she will be able to live among nations without hurting their pride or without being hurt in her own pride. Such a state of tension is profitable to the world, it could be overcome only by a love which the world hardly knows. But I maintain there is here a mystic problem which matters infinitely more (11). We cannot disregard the spiritual privilege of the race of the Virgin and Jesus. Last year some self-righteous [2] young men, to show their contempt for a bad state minister, were shouting at the top of their voices: *Abraham, hou,*

[1] *Acta Apostolicae Sedis,* November 5, 1925.

[2] "Bien pensants." This term means conservative, reactionary, and is used mainly to describe the narrow-minded, self-satisfied type of Catholic. *Tr.*

hou(13)[1] without realizing they were outraging Heaven by soiling the name of the immensely great saint whose paternity envelops all the faithful. *Abraham genuit Isaac, Isaac autem genuit Jacob* . . . that is the genealogy of our God. I re-read the XIth chapter of the Epistle to the Romans: "As concerning the Gospel, indeed, they are enemies for your sake; but as touching the election, they are beloved for their fathers' sake . . ."

It is on them that we are grafted. How could we not heed the breaths that pass over the old trunk? We must follow with much love, vigilance and respect the anxieties that disturb Jewish youth. Israel is the people-priest. Her vices are those of bad priests, her virtues those of saintly priests. I have known vain, corrupted Jews. I have known ever so many more magnanimous ones, with large and ingenuous hearts, who were born poor and died poorer still, who had neither the sense of lucre nor that of saving, and who were happier to give than to receive. If there always are carnal Jews there are also the true Israelites, *in whom there is no guile.* Would that they asked themselves, as

[1] "Hou-hou!" is a French exclamation of derision or contempt.

once did Rabbi Samuel of Fez(14), into what heart, onto what lips has passed the song of the dispossessed Synagogue!

The spirit of God is at work everywhere. The Virgin stands everywhere in the breach. The confusion of our times gives more hope than a false peace. Sin abounds in a way so monstrous that one must really think that God is preparing a super-abundance of grace that no one can imagine. It is useless to deplore the crimes of the Russian revolution. In order to smash what holds existence under a law, be it a perverted law, any revolution whatever lets loose, for a moment, against the Principle of every law that which has been repressed in man. Accordingly there is a satanic element in this Revolution. Yet the Russian revolution exists.

It would seem God was tired of the Russian order. His enemies do only what He allows; once they have swept His road clear He discharges them and gives them a character. They at once find a place in the house opposite, whence they will move no more.

We are now expecting the great outpouring of charity that so many saints have announced, that

shall create souls as universal as prayer. It is a fine thing, when the whole woof of an apostate world is being torn, to celebrate the universal Kingship of Jesus Christ. It will perforce impose itself one day; it will begin with men's minds. Love must win the game at the end of ends; wisdom must burst out laughing. Then *the rebels themselves shall live near Jehovah.*[1]

In your letter you have spoken too much about me, my dear Jean, and you have forced me to say *I* very often in this answer. This is something I hardly like, and which suits a philosopher much less than a poet. Yet I must carry on in this vein for a few more moments.

I am, as you know, a disciple, the most unworthy and the latest come, of Saint Thomas Aquinas. What am I saying? A disciple of his disciples—a Jacques of John of Gaëtan of Dominic of Reginald of Saint Thomas, all that is most byzantine, most scholastic, most contemptible in the eyes of the princes of the Sorbonne. Yet each one of us, even as he has his hairs numbered, has also his poor task as a useless servant well defined in Heaven.

[1] Ps. LXVIII (Hab), 9.

I believe I have some idea of mine; I have been riveted to the most dogmatic, keenest thought, the least capable of conciliation and softening, to a doctrine that is absolutely hard, in order to try, while contemplating our times as they pass, not to scatter but to take on, to reconcile. The fact is, I have confidence in the truth. As universal as being, truth must gather everywhere the fragments snatched from unity; she alone can do it. Minds recognize each other only in the light; the purer it is, the more it is divided from the shadows, the more it unites.

I had to start out with controversy; it bores me more and more. I know the errors that lay waste the modern world, and the fact that it has nothing great but its suffering; but this suffering I respect. Everywhere I see truths made captive. What Order of Mercy shall rise up to redeem them? Our business is to find the positive in all things; to use what is true less to strike than to cure. There is so little love in the world; men's hearts are so cold, so frozen, even in people who are right—the only ones who could help the others. One must have a hard mind and a meek heart. Not counting soft minds with dry hearts, the world is almost entirely

made up of hard minds with dry hearts and meek hearts with soft minds.

The first function of Thomist has been, and will always remain, of a sacred order: lifted upon the towers of the Church it defends theologically the divine truth against all aggression from error. The Pope has now ordered it to come down into the street. To the offense of reasonable people, who thought they had it neatly filed away in their records at its chronological place, certain that Christian scholasticism had no more in it than Moslem scholasticism or Buddhist scholasticism, the time has come for it to work philosophically in the profane world, to display throughout the world its renewed youth, its curiosity, its boldness, its freedom, and thus to assemble the scattered heritage of wisdom. For the most ambitious adventure one equips oneself with the most care; the stricter, the better defined the doctrine is, the severer the discipline, the more complete the fidelity, and the more room there will be for movement. Nothing was easier to understand. But what a program! My having had a glimpse of it is why I am pleased with nothing I do, why I think less of myself than all my critics, and were it not for charity, of which

I hope I have a spark from God, I would see in myself only disappointment and empty labor. But you do not need to be taught by me that hard positions are the only ones that are good.

In loving poetry, in giving support to our young friends wholeheartedly, I am not turning away from my duties as a philosopher, for wisdom has an eye on everything. But because I am a philosopher, I remain and must remain entirely separated from the world of art, of literature and criticism; I am no part of it, which gives me the privilege of being able to admire in it, the moment they are pure, beauties that are diverse, even opposite to each other.

Let no one say, because we are exchanging these letters, that you propose to annex my philosophy to your poetry, or I your poetry to my philosophy. We merely claim these two can love each other and remain free. Your poetry doubtless has a conception of the world, but it is too immersed in the concrete to be able to be put into a system. My philosophy doubtless has a doctrine of art, but it is too abstract to leave the heaven of principles, where so many mansions are, and which rains on the just and on the unjust. Moreover, wisdom and art

are two independent absolutes. All sciences are subordinated to wisdom by very reason of their objects. This is not the case with art: it comes into the midst of our hierarchies like a moon prince whom etiquette has not foreseen, and who embarrasses all the masters of ceremonies. Taken in itself, and in its pure formal line, it has with human and divine values neither subordination nor co-ordination, it depends by its object neither on wisdom nor on prudence; all its dependence on them is on the side of the human subject who practises art, *ex parte subjecti*. It can be mad and remain art; it is man who will pay the cost. If in the end the work must suffer, it is by a repercussion owed to material causality, because a work supposes a workman, and because the human substance of the workman shall have been devoured. Baudelaire has written on this point a decisive page.

Bona amicorum communia. Friendship puts everything in common. Doing this is a temptation, as concerns formal objects, of the philosopher and of the poet, a temptation that obsesses the best in our time, and which risks drowning our epoch in a base confusion. Let us leave formal objects un-

touched. Setting objects into confusion unfailingly results in setting subjects at variance; thus Friendship itself begets Discord, as with old Empedocles. You and I know how to preserve distinctions. Let us protect our friendship, which is founded in Heaven.

Art, from a certain point of view and for its own interests, has a free use of all things. The *imperium artis* extends as far as there are forms and beauty. Wisdom too has its empire, a universal and absolute one. It has its holy immobility. The life of art is in movement, to slough its skin is its own peculiar law, it inhabits a land given up to the fluctuations of the senses; the place where it lays its hand—you say it perfectly—quickly loses its freshness. Wisdom participates in the immobile activity that makes up the life of its objects; "God is the only freshness that does not grow warm." A philosopher would be a coward who left the eternal for the changing. Art or literature, social life or politics, he is lost if he binds himself to what is not above time. I should not be a Thomist if I did not know these things. Having here below no other task than to testify as best I can for wisdom, I owe myself to all whoever they may be who

seek it. I know what my object is—a greater than I has put me to it. *Tenui, nec dimittam.*

On this condition I have a temper free enough to suffer as is needed. A terrible pity rends me at the thought of the generation that is twenty years old today. The best among them go to the worst. Whose fault is it? That of the abominable world of which they are victims. And especially ours, we Catholics. For we are responsible for everything, having the redeeming light in our wicked hearts of men. Insofar as we stop it and diminish it, we increase the weight of darkness. (And insofar as we are faithful to it, we carry this weight with Christ.)

"When you think you are hating your enemy," Saint Augustine says, "most often it is your brother you hate, and you don't know it." Many of those who believe themselves to be our enemies are in reality closer to us than they think, or than we think. They desire with remarkable impetuosity this same God that we love, that we do not love enough. If we had loved Him more, would they not know Him? All they know of religion is a vague Cartesian caricature, they see in it nothing but rites without meaning, a set of comfortable morals. The

modern world has taught them that God works Himself out in man; it has turned the order of things upside down, making the Pure Act dependent upon us. From the premises they have been taught they have at least the merit of drawing the conclusion: Despair. Alas, they seek God in the destruction of themselves. The instinct of their immortal soul, the instinct even of baptism formerly received by most, throws them toward an absolute they believe they must invent, unaware of the fact that He is here, more intimately in them than they in themselves, for it is He Who has made them. A saint reaches his arms out to them, having found what they were seeking: of the false night of the sleepwalker only the night of Saint John of the Cross can cure them (14).

Your letter, my dear Jean, "closes a loop that begins with *Le Coq et l'Arlequin.*" As for me I must return to the *Logica Major* and to the *Prima Philosophia,* to the theory of the four modes of *perseitas,* to the great quarrel of the *Quo* and the *Quod.*

<div align="center">

J.

Meudon, January 1926

</div>

NOTES

(1)

I have tried to show this in an article in *Art and Scholasticism* (Third Edition, Appendix 1) and in *Art and Poetry*.

(2)

Or rather the author of the Ethics to Eudemius: "It will perhaps be asked whether it is somebody's good fortune that makes him desire what he should desire, and when he should. Without thinking, deliberating, or taking counsel, he happens to think of and want what is most suitable. What is the cause of this, unless it be good fortune? Yet what is it, in itself, and how can it give such happy inspirations? This is like asking oneself what is the superior principle of the movements of the soul. Now it is clear that God, Who is the principle of the universe, is also that of the soul. All things are moved by Him, Who is present in ourselves. . . . The principle of reason is not reason, but something superior to it. What is superior to

reason and to intelligence, if not God? That is why the ancients said: Happy those who, without deliberating, are moved to do well. This comes not from their will, but from a principle present in them, which is superior to their intelligence and to their will. . . . Some, under a divine inspiration, even foresee the future."

The ancient philosophers are not alone in recognizing this special motion of God in the natural

Our mind is moved by God

In the natural order
- to desire beatitude in general.
- to turn itself toward such and such a real good or apparent good.
- THROUGH A SPECIAL INSPIRATION, for example, of a poetic or philosophical order.

In the supernatural order
- to convert itself toward God, Who is the supernatural last end.
- to make use of the infused virtues.
- through a special inspiration to which the gifts of the Holy Ghost make us docile.

order; theologians recognize it also. I shall copy here the synopsis drawn up by Father Garrigou-Lagrange, to classify the various modes of divine motion (*Vie Spirituelle,* July 1923, Page 419).

(3)

One forgets too often that ideas, *representations,* are for the poet nothing more than a means, and a sign. You were telling us this on one of those last evenings, that one nearly always makes a mistake in judging poems: a *clear* poem is a crystal, an *obscure* poem is an agate. People admire the first because through it they see things they recognize; they condemn the other because it allows nothing to be recognized through it; or else they admire it because they notice veins in it, shadows that seem to look like something. Purity of matter and of the cutting was what they should have looked at. And the spiritual ray that is reflected in it.

(4)

Doing [1] (*agibile*), in the restricted sense in which the scholastics understood this word, consists in the

[1] "L'agir." *Tr.*

free use, insofar as it is free, of our faculties, or
in the exercise of our free will considered not with
regard to things themselves and to the work we
produce, but purely with regard to the use we make
of our freedom. . . .

In opposition to Doing the scholastics defined
Making [1] (factible) as *productive action,* consid-
ered not as it relates to the use that in this or that
action we make of our freedom, but *purely with
relation to the thing which is produced,* or to the
work taken in itself.

This or that action is what it should be, it is good
within its order if it conforms to the rules and to
the proper end of the work to be produced : and the
effect it achieves if it is good is that this work is
good in itself. Thus Making is ordered to such and
such a particular end, taken in itself and sufficing
unto itself, not to the common end of human life ;
and it is concerned with the good or the perfection
peculiar not to the man operating, but to the ef-
fected work.

The domain of Making is the domain of Art,
in the most universal sense of the word. (*Art and
Scholasticism.*)

[1] "Le faire." *Tr.*

(5)

"The artist must be," (excuse me for repeating what I have already said elsewhere [1]), "fundamentally kept to the line so far as the end of art is concerned; he must be perpetually on the watch not only against the banal attraction of facility and success, but against a multitude of more subtle temptations, and against the least slackening of his inner effort. He must journey across nights, he must purify himself without ceasing, he must of his own will leave fertile regions for regions that are arid and full of insecurity. In a certain order and from a particular point of view, in the order of "Making" and from the point of view of the good of the work, he must be humble and magnanimous, prudent, upright, strong, temperate, simple, pure, ingenuous. For this reason he easily takes the tone of a moralist when he is speaking or writing on art, and he knows clearly that he has "a *virtue* to keep." On which subject I quoted you: "We are sheltering an angel that we shock continually. We must be the guardians of this angel. Cover up well your virtue of making miracles, for

[1] In *Art and Scholasticism.*

⨍ 125 ⨍

if they knew you to be a missionary they would tear out your tongue and your nails." [1]

(6)

Let me set down here some excerpts from a letter from Father Surin, the great spiritual who exorcized the possessed of Loudun, and who himself was possessed for twenty years.[2] He wrote to his colleague, Father d'Attichy, a Jesuit at Rennes.

". . . Since the last letter I wrote you I have fallen in a state far removed from what I expected, but in full conformity with God's Providence over my soul. I am no longer at Marennes, but at Loudun, where I received your letter. Since recently I have been in perpetual conversation with devils, in which I had adventures that would be too long to recount to you, and that gave me more reasons than I ever had to know and admire God's goodness. I should like to tell you something about it, and I would tell you more if you were less talkative.

[1] From *Le Coq et L'Arlequin.*
[2] He lived also on the borderline of insanity. But as concerns his possession I prefer to believe his testimony rather than the hypotheses of psychiatrists who discuss his case retrospectively.

"I got into a combat with four of the most power-
ful and malignant devils of Hell—me, I repeat,
whose weakness you know. God allowed the strug-
gles to be so violent, and the approaches so fre-
quent, that exorcism was the less dangerous battle-
field, for the enemies declared themselves in secret
day and night, in a thousand different ways. You
can imagine what a pleasure it is to find oneself
at the mercy of God alone. I shall tell you no more
about it; it is enough for me that, knowing of my
state, you take occasion to pray for me; such is
my condition that for three and a half months I
am never without an active devil beside me. Things
have come to such a pass that God has permitted,
I suppose, for my sins, what has perhaps never been
seen in the Church; namely, that in the exercise of
my ministry the devil passes from the body of the
person possessed and, coming into mine, assaults
me and knocks me down, shakes me and visibly
goes through me, having possession several hours
over me like a lunatic. I could never explain what
goes on in me during this time, and how this spirit
becomes one with mine without removing either
my consciousness, or the freedom of my soul. He
makes himself at the same tme like another self

of mine, as if I had two souls one of which is dispossessed of its body and of the use of its members, and holds itself back, seeing the activity of the other that has entered into me. The two spirits fight each other on one and the same field, which is the body, and the soul is as if divided : one part of it is subject to the diabolical influences, and the other to its own real impulses, or to those God gives it. At the same time I feel a great peace that is at God's mercy, and without my knowing how there comes to me an extreme rage and an aversion for Him which produces a craving as it were, for being separated from Him, which astonishes those who witness it ; at the same time I feel a great joy and peacefulness, and on the other hand a sadness that is expressed by lamentations and cries similar to those of devils. I feel the state of damnation and I fear it, and I feel as if pierced by shafts of despair in this foreign soul that seems mine ; and the other soul, full of confidence, derides such feelings, and with perfect freedom curses him that causes them ; I even feel that the very cries which come out of my mouth come from those two souls equally, and am at pains to tell whether they are produced by joy, or the extreme frenzy that fills me.

The tremblings which seize me when the Blessed Sacrament is given me come as much, it seems to me, from the horror of His presence, which is unbearable to me, as from a heartfelt and sweet reverence—without my being able to ascribe them to the one rather than to the other, and without its being in my power to restrain myself. When I want, by the movement of one of these two souls, to cross myself on the mouth, the other pushes my hand away with great speed, and seizes my finger in its teeth, to bite it out of rage. I rarely find my prayers easier and more peaceful than when I am in these agitations. While my body rolls about and the ministers of the Church speak to me as to a devil and load me down with maledictions, I could never tell you the joy I feel; having become a devil not through rebellion against God, but through the calamity that genuinely sets before me the pass to which sin has reduced me, and the way in which, taking on to myself all the maledictions that are given to me, my soul has reason to lose itself in its nothingness. . . . What a favor it is to know by experience from what a state Jesus Christ has drawn me, and to feel how great is His redemption, no longer through hearsay, but by

undergoing this very state, and how good it feels both to have the capacity to enter into the misfortune, and to give thanks to the goodness that has freed us from it at such labor! That is where I am at, at this hour nearly every day. Great arguments arise over all this *et factus sum magna quaestio* as to whether or not it is a case of possession; whether it is possible for ministers of the Gospel to fall into such grave mishaps. Some say it is a punishment of God upon me for some delusion. Others say something else, and I just hold still and I would exchange my fortune with no one else, having the firm conviction that nothing is better than to be reduced to great extremities. . . ." [1]

(7)

"Man's heart," says Freud, "is hollow and full of dirt." No, it is Pascal who speaks thus.

(8)

Gide's great weakness is that he refuses after that to admit that these regions are in reality lower

[1] I have borrowed the text of this letter from the work of l'Abbé Leriche, *Etudes sur les possessions et sur celle de Loudun en particulier,* Paris, Henri Plon, 1859.

than others. Thus he travels only in flat country.
To believe in the Devil is good. After which, to
want to marry Heaven and Hell is precisely to
deny the Devil.

(9)

"The Church," says Bossuet, "is Jesus Christ, but
Jesus Christ spread about and communicated."
"The whole mystery of the Church," wrote Father
Clérissac,[2] "lies in the equation and convertibility
of these two terms: Christ and the Church. This
principle lights up all the theological axioms con-
cerning the Church. For example, *Outside the
Church no salvation* really means nothing other
than: *Outside of Christ no salvation.*"

The Church is visible and she is immense. All
baptized persons are incorporated into her, as liv-
ing members if they have grace, as dead members
if they have lost charity. But she also carries within
her, as members not yet incorporated, nevertheless
invisibly united to her soul, all the unbaptized in
the state of grace, in whatever error they may be
in good faith. So that all that is of God is also
of her.

[2] In *Le Mystère de L'Eglise.*

(10)

In the same way, saints extend their prayer. It is thus that Saint Gertrude wanted to recover all love for Jesus:

"At another time, while during this same Feast (Epiphany) these words of the Gospel were being read: *'Et procidentes adoraverunt eum*: and going down on their knees they adored Him,' she was aroused by the example of the Blessed Magi, she got up in spirit, in great fervor, and threw herself at the feet of the Lord with the most humble devotion, to adore them in the name of all that exists in Heaven, earth and Hell. But as she could find no offering worthy of God, she took to wandering about the world in anxious desire, seeking in all creation something that could be offered to her unique Beloved. As she ran in the thirst of her fervent desires, panting and burning with love, she found contemptible things which all creation would have rejected as unfit to contribute to the praise and glory of the Savior. Yet she took hold of those things with avidity, in order to take them back to Him Whom every creature must serve alone.

She thus attracted to her heart all the miseries,

the sufferings, the fears and the anxieties that creatures can have suffered, not for the glory of the Creator, but as a consequence of human weakness, and she offered them to the Lord as a choice myrrh. In the second place she assembled all the false sanctity and show of devotion that hypocrites have affected, Pharisees, heretics, and people of that ilk, and presented them to the Lord as the sacrifice of an agreeable-odored incense. As a third offering she tried to collect natural affection and even false and impure love spent in vain by so many creatures, in order to present them to God as a very precious gold. In virtue of her ardent and loving desire that tried to bring all things to the glory of her Beloved, these miserable offerings became as gold purified in the furnace, separated by melting from all its dross. She offered them to the Lord after having passed on to them this marvellous value." (*Le héraut de l'Amour divin,* book IV, ch. VI).

(11)

Later on I have had the opportunity of setting down more completely my views on what is called the Jewish question. Cf. *A Christian Looks to the*

Jewish Question (Longmans Green, 1939) ; *Ransoming the Time*, chapters VI and VII (Scribners, 1941) ; *Pour la Justice* (La Maison Française, New York, 1945).

(12)

Écho de Paris, Monday, May 11, 1925. "All of a sudden it is Mr. Schrameck, on the air of the *lampions*,[1] who is the goat of the day. Thousands of untiring voices sing: Abraham, hou! hou!"

(13)

"An apology, *'de Adventu Messiae praeterito,'* written around 1070 by a converted Jew of Morocco (Rabbi Samuel of Fez), notes this mark of divine institution in the fact that the lyricism of the Synagogue has passed into the Church, which alone sings the new and universal Canticle called for by the Prophets." (H. Clérissac, *Le Mystère de L'Église.*) Cf. Dom Rabory, *Le Chant Chrétien Preuve de la Divinité du Christianisme,* Univers, July 10, 1912.

[1] The air of the *lampions* is the tune usually adopted by crowds in a public demonstration for the repetition of some short phrase, preferably abusive. *Tr.*

(14)

With what rapidity sometimes, you know. A tragic and blessed example recently showed it to us. We saw God then carry off like a thief His loot to Heaven.

Index

INDEX